Focus On
Lighting Photos

The *Focus On* Series

Photography is all about the end result—your photo. The *Focus On* series offers books with essential information so you can get the best photos without spending thousands of hours learning techniques or software skills. Each book focuses on a specific area of knowledge within photography, cutting through the often confusing waffle of photographic jargon to focus solely on showing you what you need to do to capture beautiful and dynamic shots every time you pick up your camera.

Titles in the *Focus On* series:

Focus On Lighting Photos

Fil Hunter and Robin Reid

ELSEVIER

AMSTERDAM • BOSTON • HEIDELBERG • LONDON • NEW YORK • OXFORD • PARIS
SAN DIEGO • SAN FRANCISCO • SINGAPORE • SYDNEY • TOKYO

Focal Press is an imprint of Elsevier

Focal Press is an imprint of Elsevier
225 Wyman Street, Waltham, MA 02451, USA
The Boulevard, Langford Lane, Kidlington, Oxford, OX5 1GB, UK

Notices

Knowledge and best practice in this field are constantly changing. As new research and experience broaden our understanding, changes in research methods, professional practices, or medical treatment may become necessary.

Practitioners and researchers must always rely on their own experience and knowledge in evaluating and using any information, methods, compounds, or experiments described herein. In using such information or methods they should be mindful of their own safety and the safety of others, including parties for whom they have a professional responsibility.

To the fullest extent of the law, neither the Publisher nor the authors, contributors, or editors, assume any liability for any injury and/or damage to persons or property as a matter of products liability, negligence or otherwise, or from any use or operation of any methods, products, instructions, or ideas contained in the material herein.

Library of Congress Cataloging-in-Publication Data
Hunter, Fil.
 Focus on lighting photos : focus on the fundamentals / Fil Hunter, Robin Reid.
 p. cm.
 ISBN 978-0-240-81711-8 (pbk.)
 1. Photography—Lighting. I. Reid, Robin, 1949– II. Title.
 TR590.H839 2011
 778.7′2—dc22

 2011009663

British Library Cataloguing-in-Publication Data
A catalogue record for this book is available from the British Library.

ISBN: 978-0-240-81711-8

For information on all Focal Press publications
visit our website at www.elsevierdirect.com

Printed in China

11 12 13 14 15 5 4 3 2 1

Typeset by: diacriTech, Chennai, India

Dedication

To Polly Frye, who tirelessly organized and educated generations of photographers who wanted to learn.

And, to Polly Frye, who said to Fil and Robin 30 years ago, "I think you two need to get to know each other better." We took her advice.

Thank you, Polly.

Contents

v Dedication

ix Acknowledgments

xiii Introduction: Lighting? Why Bother?

3 **Chapter 1: There's More Than One Way to Get Things Done**

5 Built-in flash

7 Modifier 1: A mirror

9 Modifier 2: A big white reflector

11 Other modifiers: Fill light, hair light

13 Same principle: We can control the size of the light in many ways

16 Adding another light

23 **Chapter 2: Tools: Now We Have Light, but How Do We Get It under Control?**

25 Off-camera flash

27 How to trigger flash

32 The size of the light

35 But what if we don't have a wall or a ceiling to use for bounce?

59 Now, get to work!

61 **Chapter 3: The Color of Light**

73 Using gels for dramatic color

79 **Chapter 4: Light and Shadow**

83 Texture

86 Why does the same light look so different on another subject?

91 **Chapter 5: Sunlight**

92 Found light

97 Amending or mixing light

103 Distance and haze

104 Architecture

107 **Chapter 6: So, Where Do We Put This Light for Portraits?**

109 Split lighting

111 Short lighting

112 Broad lighting

113 Hair light

115 Background light

116 Rim lighting/kicker

118 Butterfly/Beauty lighting

120 Low key versus high key lighting

Contents

127 The wrinkle

128 Eyeglasses and lighting: Can they get along?

131 Groups

135 Pets

141 **Chapter 7: So, Where Do We Put This Light for Metal?**

144 Flat metal

147 Round metal

151 **Chapter 8: So, Where Do We Put This Light for Glass?**

152 Dark-field lighting

154 Bright-field lighting

157 A glass half full

158 Glass and paper

160 Bottles and more

165 **Chapter 9: Motion**

165 A bit of motion

167 Lots of motion

171 Freezing motion

175 **Chapter 10: The Future Is Now?**

175 New light sources

176 Postproduction

177 High dynamic range imaging

183 **Conclusion**

184 **Glossary**

196 **Index**

Acknowledgments

OUR THANKS TO the contributors who generously made images available for us to use in this book. As you'll see, some are professionals, but others are novices or hobbyists. It doesn't really matter which is which. Both of the authors, Robin and Fil, made some fairly decent images as amateurs and then went on to make a (hopefully very) few terrible ones as professionals. We are all still learning. We must help each other.

Thanks, too, to Wein and PocketWizard, for allowing the use of images of their products, and to our various models: Mandeep, Karina, Joshua, Nancy, Maggie, San, Cathie, Maggie, Wendell, Stephanie, Katie, Joanne, Jan, Jason, and Robert.

A bit about our photographic contributors:

Chris Brearley: I have no biography. I'm just a QA test engineer who enjoys taking photos. Although I tend to prefer staying in the studio, I'm trying to get out more and see what is around me. Page 166, fireworks.

Alesa Dam: Born in 1971, Belgium, I have been intrigued by photography since my childhood. As a child I owned a Kodak Disc film camera. My father was interested in photography himself and had some books about the subject on the bookshelf. Love, study, and my first job got in the way of this hobby in my late teens and twenties. I regained interest in photography when we switched from disposable film cameras to our first, and only, digital point-and-shoot back in 2001. My first DSLR, bought secondhand in 2009, opened up a new world full of creativity. Being more involved in photography for only 2 years, I'm not really clear yet what direction it's taking me, but it seems my preferred subjects include long-exposure night photography, abstracts, and studio portraiture. Page 174, LEDs.

Joel DeYoung: Based in Holland, Michigan, I began my photographic journey in 2006 and found that the challenges of photography fit well with my inquisitive personality, my love of nature, and my need for artistic expression. Through photography, I have been able to experience and explore the world in new and wonderful ways, finding and photographing details in nature that most people overlook. From the grand landscape to the tiniest insect, I have found that the world is full of beauty when you take the time to notice. Contact me at joel@joeldeyoungphotography.com. Page 96, boy's head shot.

John Hartman: John Hartman is a professional photographer who has done fine art and commercial work for more than 25 years. He works from a studio in Alexandria, Virginia, and produces assignment and stock imagery that is published in magazines every month. John is the son of Henry Hartman, a nationally known illustrator and fine artist. His long-standing interest in nautical subjects has led to collaborations with various

boating publications including *Chesapeake Bay* magazine, where he has been a part of the creative team for 13 years. John's approach to photography is one of discovery, and he describes his personal creative process as "visual exploration." On land he sees himself as a "street photographer" at heart. Through a busy shooting schedule, he produces an average of 30,000 images annually. His prints have received "Best of Show" recognition in juried gallery competitions, and his magazine work has won several publishing awards. Eastman Kodak has used his imagery in its advertising. John has taught photography at the Art League School in Alexandria, Virginia, for 10 years, and he served 6 years on the Art League's board of directors. He is a member of the American Society of Media Photographers (ASMP), Nikon Professional Service (NPS), the Stock Artists Alliance (SAA), and the Society for Photographic Education (SPE). In addition, John offers fine art prints including abstracts, water- and sea-related subjects, and musicians in concert. Visit both of his sites to see more at www.johnhartman.com and www.hartmanfinearts.com. Page 92, boat.

Erik Heitfield: Erik Heitfield is an amateur photographer living in Washington, D.C. He has enjoyed photography all his life, but he only recently began experimenting with the use of off-camera flash and do-it-yourself light modifiers. He credits his knowledge of photographic lighting to the book *Light—Science & Magic,* to David Hobby's strobist.com blog, and to his many friends on Flickr. You can view Erik's other work on Flickr.com under the screen name "EriksWeeklyPhoto." Page 13, girl with hat; page 14, DIY softbox.

Paul Hodgson: I run a successful wedding and portrait business in the UK along with my wife, Nikki Hodgson. While located in the north of the UK, it's not uncommon for us to travel outside of the UK for commissions. In my spare time I still take photographs and have an equal interest in capture and postproduction. PP doesn't mean oodles of pixel destruction, just sharpening in all the right places and correcting any exposure errors. Surely not! We can be found at www.bof.uk.com, which stands for Box of Frogs. Page 67, both church images.

David House Sr.: David House Sr. is a photographer in Lapeer, Michigan. His web page, www.LapeerPhotography.com, includes a representation of his work. His primary focus is commercial photography and portraiture. His 25-year journey into photography has been largely self-taught, as he knew no one with any knowledge about photography in the beginning. So he read books and magazines, asked a lot of questions, experimented, and tried new things. His nature photography is the opportunity to get back to what was his first photographic love, nature and landscapes. Because he is comfortable with lighting and flash in the studio and on location, he often uses similar, yet modified, techniques in the field. Page 102, mushrooms and outdoor setup.

Fil Hunter: Professional photographer from the age of 17. While achieving a double major in psychology and religion, served as principal photographer experimenting with the predistortion of images so that they would appear undistorted on a planetarium dome. Lead author of *Light—Science & Magic,* the first book to establish universal principles of lighting.

David Kittos: I'm a UK-based, amateur photographer currently

living in Surrey. My first photography experience was a rather unsuccessful attempt at underwater photography during a scuba diving holiday in the Red Sea in 2005. Just like a bad workman who blames his tools, I still blame the camera I used at the time for my lack of success! It was a cheap and nasty $10 box that I bought in a local scuba shop. At some point I upgraded to a real camera, this time an Olympus SP350 with an underwater housing and a very expensive underwater flashgun. Things moved quickly from there. Photography proved way too much fun to do only during my diving holidays, so I bought an Olympus DSLR, a copy of *Light—Science & Magic,* and 2 years later I'm still learning new stuff and have built up a diverse portfolio. My interests include glassware photography, off-camera flash (speed lights and studio work), high-speed photography, and working with alternative models. I'm also an occasional contributor to photography magazines, and my work (pictures and articles) has been published in various UK and web publications such as *Underwater Photography* web magazine (uwpmag.com), *DSLR User, What Digital Camera* (Flash Supplement), and *Olympus User.* Page 87, night lights; page 90, dusty road; pages 164, 171, strawberry; page 173, set-up; page 182, baboon.

Anton Lenke: Anton Lenke remains enigmatic. Some say he has shot Czech supermodels while hanging out of an airplane. Others claim he can build a camera with a shoebox, a dart, and the chain from a 1957 Harley Davidson. The superhuman stories continue to grow, but the proof is in the portfolio. For more, visit Antonlenke.com or contact him at antonlenke@gmail.com. No capes. Page 50, grid background.

Ryan McGehee: When I was 18 I graduated from the New York Institute of Photography (having enrolled when I was 16). This helped start me on my journey of photography. Now, many years later, my passion for this art has continued to increase. I enjoy capturing the beautiful moments in this world. Photography allows me to create works that I can share with others, that which I see and feel. It may be an entire valley below me or the way the shadows fall on the snow. It may be the way the light ripples across the water or the perfection of a little detail. Whatever it is, it is that which I connect to, that I become a part of. This I try to capture the essence of, that feeling, that moment. Knowing that I will always be a student in this amazing craft, I continually try to learn how to capture and present this beautiful world at its best. I want to be able to connect the viewers of my work with the beauty, uniqueness, and poetry of this world through my eyes, my photography. They tell me a person can get a lot by asking, so if you're looking for a photographer, I would love to have the opportunity to bring my vision to your commercial or editorial project. Contact me at ryan@ fleetingmomentsphoto.com or visit www.fleetingmomentsphoto.com. Page 63, mountain lake; page 65, girl at dock; page 66, water ripples; page 99, man with hat.

Jeremy Millar: Jeremy Millar is a Sydney-based photographer. Working with portable lighting, Jeremy likes to experiment with simple lighting setups for portraits and dance photography. You can see more of his work at www.ensofoto.com. Page 101, ballerina; page 166, male dancer.

Robin Reid: Trained as a classical pianist, loves Motown and the Rolling Stones anyway. Degree in international politics, danced professionally for 15 years. Still works as a portrait and commercial photographer and graphic designer, with a particular penchant for book design. Teaches regularly for the Alexandria Art League.

Rishi Saikia: Rishi is an up and coming photographer from India, specializing in portraiture. He has a distinctive minimalist style of lighting that helps preserve, and at times create, a signature mood in his images. Rishi embarked on his photographic journey about 7 years back when he happened to come across Fil Hunter and Paul Fuqua's amazing book *Light— Science & Magic: An Introduction to Photographic Lighting.* He is self-taught but considers the online photographic community at Flickr as a major source of learning and inspiration. Rishi's latest images can be found on his Flickr stream (Rishi S). He also maintains a blog (www.rollon.in) where he documents his photographic journey, detailing every photo shoot—the entire process of conceptualizing, executing, and postprocessing his images. He accepts requests for photo shoots via his Flickr mail. Page 74, smoker; page 116, woman.

Adam Sewell: I am 37 years old and have lived in and around South East England all my life. I first started photography to document the growth of my family, preferring the power of the still image as a medium; it is an ongoing and wonderful project. I also venture into still life as a way of exploring shape and form and have taken on some commercial work, although my family project remains my passion. Contact me at asimaging@btinternet.com. Page 64, mountain snow; page 105, clock tower.

Ivan Sorenson: Ivan Sorensen is from Hamilton, Ontario, Canada, and has been involved in photography since the mid-1970s, shooting weddings and developing and printing from a home darkroom. Although he has not been a full-time hobby photographer for many years because of the vagaries of career and family, he has returned to the world of digital imaging, specializing in fine art landscape prints and the odd portrait thrown in for balance. Ivan's work has been included in several galleries, such as the summer issue of *PhotoNews* magazine, several commercial websites, and this fine instructional book by Fil Hunter and Robin Reid. Contact him at ivan.sorensen@hotmail.com or visit www.flickr.com/photos/pics_by_ivan. Page 60, morning lake; page 3, grapes.

Tony Traub: I am totally self-taught and have been shooting since I was a teenager. I started with a Minolta xg1, I believe, and have used various film cameras over time. My favorite types of photos back then were mostly about my camping trips with friends and the scenery around our different campsites. I got into digital about 3 to 4 years back. My first digital camera was a Nikon d50, which I still own. I now use a Nikon d300, which is an excellent body. I still use my d50 though and think it's also an excellent camera as well. I also have a Nikon n80 for when I like to play with film. I hope to get into medium format photography some day and start to learn landscape photography. As of now, I mostly shoot still life/tabletop photography because I like the total control you have over lighting and setup. Page 75, whisks.

All unattributed images and diagrams are by Robin and Fil.

Introduction: Lighting? Why Bother?

Modern digital cameras can do everything for us, right? They focus accurately. They get a good exposure almost every time. We've got the sun, and our built-in flash, and maybe an additional more powerful flash, as well as all their manuals, so why do we need to learn about light?

If we need more light, we can just use that built-in or popup camera flash, what we'll refer to as *built-in flash*, and we get as much light as most people need. Still not enough light? Don't have a built-in flash? Just put one of those smart dedicated flashes on the hot shoe, the ones that intelligently measure their own reflected light and know when the light is enough and turn themselves off. We can even set them to communicate with the camera so that the camera sees both the flash and the ambient light and adjusts intelligently between the two.

It's easy these days. The smart camera and the smart flash do the hard thinking for us; all we need to do is to concentrate on our art.

But you're not buying any of this misinformation are you? Or at least not all of it. That's why you bought (or borrowed or stole) this book in the first place. There has to be more, but what is it? More equipment? Sometimes, but not usually. Better pictures mostly require simply understanding how to use whatever light we have.

There is more. It's not difficult to learn, and you have the guidebook in your hands right now. The key is learning how light works and how to get it where you want it and with the quality of light you need, and that means turning off all smart settings *for now*. If you

Any terms you do not understand here? Check in the glossary at the end of this book. In fact, if controlling light is new to you, you may want to at least skim the glossary right now.

There IS more!

learn to work with simple, *dumb* lighting—where *you* do the thinking—you'll get great images with simple equipment. If you've got one of those dedicated flashes already and learn to work with it in *manual mode* first, *you'll actually make better use of its sophisticated capabilities afterward.* For our purposes here, we want the camera and any flash we have to be set to manual, so we're making all the decisions.

Sometimes we *find* the light; everything is perfect—shoot now, don't wait! But to do that, we have to learn to *see* that the light is perfect. We also need to *see* when the light is wrong and decide what to do about that "wrong" light. Often we can fix problems; sometimes we don't bother. If it's our best friend's wedding, we hope that milestone is not ever going to happen again and we take the picture anyway. We don't get another chance on that one.

There will be other times when the light is bad, but we can at least help it very quickly: pop up that built-in flash (or turn on the flash we've already attached to the camera, just in case we needed it) to fill shadows if a face is sunlit entirely from the back. Sometimes this will make quite a beautiful picture, but often not so beautiful. There's no magic in when it happens right and when it happens wrong, though (unless it's the magic of our own brains). The difference between the good and the bad depends on whether we learn to see the difference and whether we have time to fix the problems. Balancing the relative brightness of the flash and the ambient light makes a huge difference, and doing that requires time for us to think. Timing and learning relate, though. If we learn better, we can work faster. That gives us more time.

Finally, there will be many, many times when putting the flash on the camera is the worst thing to do. Still, what if the only flash we have is the one built into the camera? We certainly can't disassemble our cameras to put the flash somewhere else. That's a job for engineers, most (not all) of whom have put so much effort into learning their craft that they haven't had time to learn photography as art. At the same time, we need to learn *some* engineering to be good photographers.

Learn engineering! Horrors!
No, not horrors at all, for two reasons. First, the engineering we need is mostly stuff we already learned when we started to use our eyes as babies, but it's sitting in the unconscious back of our brains. There's nothing new to learn; we simply need to move what we already know from the back to the intelligent front of our brains to become *aware* of what we already know. The second good news is that the engineering can be cheap. All of us want an amount of photographic equipment with a value approximately equal to our national debt (in whatever nation we live). At the same time, we can often do as much with pieces of cardboard and aluminum foil.

In our cover photograph, the important light source was the built-in flash. It was the *only* flash used. Most people's reaction when they learn this is to say, "No way!" This little flash is not known for creating such beautiful light. Its light always comes from the front of the camera, which doesn't seem to be what is happening in this portrait. If you have a white wall (or white paper taped to a colored wall), some cardboard, and silver foil, you

can do this picture, too. We'll talk you through it in Chapter 1.

Our goal here is to give you enough knowledge of lighting—whatever the source—that you can take great photos without a ton of gear or expensive strobes. We also want you to understand the lighting *before* you make any more significant equipment investment. If you decide you must have one more light, not attached to the camera, get the least intelligent, least expensive you can find. It will always be useful in the future when you need one more light in a complex arrangement.

Later, if you need a more expensive flash, or a whole studio filled with strobes, you will know better what works, spend your money more wisely, and get a lot more from your investment.

In the meantime, learn about light. Join a camera club, where there is enthusiasm plus a great willingness to exchange information. Share what equipment is available. If each of you can afford to buy only one cheap light, together you can outclass many professional studios. We'll also show you how to make all sorts of tools, which photographers need on occasion. The camera and the little built-in flash or an off-camera flash often are not enough. Sometimes we need to make a little light bigger. Sometimes we need to restrict the spread of a light. There are tools to do this. Most can be homemade. Experiment. Make a homemade softbox, snoot, grid, and gobo. There are samples of all in the book, as well as excellent photos using them. Tape a white sheet to a colored wall before investing in seamless paper. Learn what you like to work with—what helps you get the photos you want. If you find yourself wearing out your homemade versions, then it's time to upgrade. But while you're learning, save your money.

Professional equipment is great—it's made to hold up for a career. But it tends to be expensive. Resist the urge to run out and buy stuff. Rather like exercise equipment, for all too many photographers (professional and amateur), these tools just gather dust all too often. Until you're ready for the investment, make your own tools or rent them or borrow them. In the long run, you'll end up with equipment you actually use and not waste money and stuff your basement with cool gear you don't use.

Photography has always been exciting. Today, we don't have to wait for the film to be processed to know if we got the shot. With digital, we know immediately. It's an ever-changing field. New technology. New software. Boy, it's fun. However, with more knowledge and a few tools, you're more likely to get the image you want and get it faster.

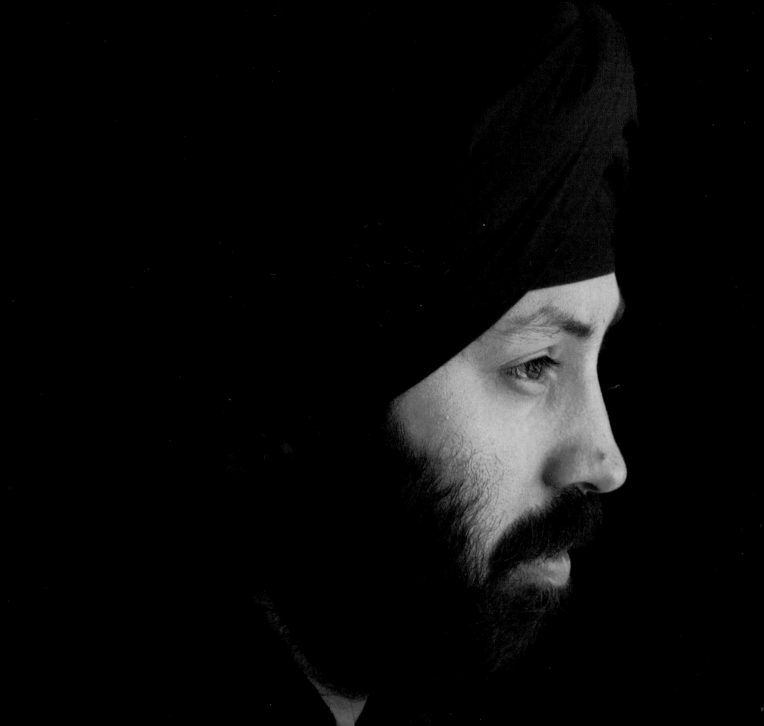

Chapter 1: There's More Than One Way to Get Things Done

WE'LL START WITH profile lighting. It's fairly easy. This is not lighting we'll often use, because it works only with one head position. Okay, two positions: camera-left and camera-right, essentially the same thing done from each direction. Still, the subject doesn't have to "pose" for the picture. Well, the person does pose, but because the subject doesn't have to face the camera, he or she doesn't have to interact with the camera. The subject need not be friendly, dignified, warm, assertive; any emotion or no emotion will work. This gives us two advantages.

First, we don't need a professional model, performer, or actor. Nor do we need to try to turn a "real person" into a professional subject. This makes things easy for the subject. "Just sit there, and I'll do the rest."

Second, because we don't have to direct the subject very much, we can concentrate just on the lighting. Later, when we're sure we know the lighting so well that we don't have to think about it much, we can then concentrate instead on directing the subject to look as good as possible.

Because we don't have to worry much about posing and emotion, we'll concentrate mostly on the simple mechanics of how the light behaves. This light will behave in exactly the same ways with other poses, but let's learn about that behavior with an easy pose.

What's this "camera-right" business?

It's a term invented in theater and dance at least 500 years ago. "Stage right" means the right side of the stage as the audience sees it, the opposite of what the performer sees. This makes sense in photography because, despite the ego of the photographer, the camera is the audience, not the performer.

Built-in flash

Shot with built-in flash.

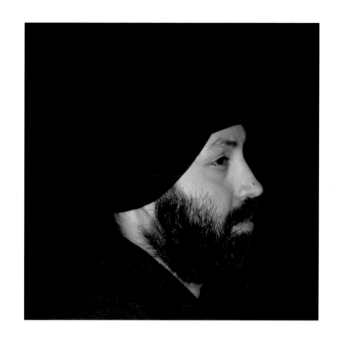

Built-in flash.

Boooring!

We made the portrait on page 5 with the camera's built-in flash. It's an okay picture: the composition is acceptable, the posing is good, and the exposure is perfect. Still, it's not a picture this man is eager to hang on the wall. We must improve it, and we can.

The cover shot was done with the *same* on-camera flash and *no* additional lights. The difference is in the use of *light modifiers*. The box describes the modifiers we used for this picture.

LIGHT MODIFIERS

Whether we use the simple light built into the camera, studio strobes costing several thousands of dollars each, or (most likely) something in between these extremes, we often find that our lights will not do what we want without modifiers. There are dozens of light modifiers. We'll buy some and make more, but there are four general types we need to know about. For now, we'll talk about the ones that make this picture work, but you'll find a more complete catalog of light modifiers in Chapter 2.

Modifier 1: A mirror

Having the flash built into the camera certainly doesn't mean we have to keep it there. Even if the flash is built into the camera, we can move its *effective* location, and we can do that ourselves without a team of electronic and mechanical engineers. Here's how.

We need a mirror to move the light to where we want it to be. We angle a mirror in front of the camera flash so the light bounces from this mirror to where we point it. This allows us to put the light almost anywhere we want it. (In fact, we could put the light absolutely anywhere we want it, but that would require a series of mirrors, light bouncing from one to another. After reflecting from all of those mirrors, the light would be about as bright as a candle in a coal mine! We wouldn't try that.)

What sort of mirror do we use? Anything we have handy, but here's a good way to make a simple, lightweight, safe, unbreakable one. First, get a sheet of silver Mylar film. (Mylar is a DuPont brand name and the product may be available under

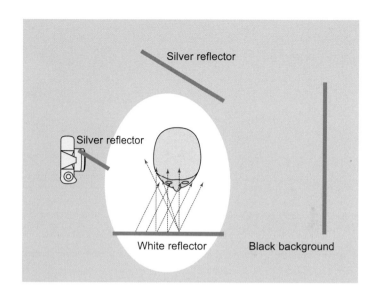

different names where you live.) Compared to other photographic equipment, it's cheaper than dirt; buy a little more than you need. You'll use it again.

Now glue some of the Mylar to a thin, stiff board and cut it to approximately the area the flash will illuminate. At such a close distance, this will certainly be less than 3 by 5 inches and may be much smaller than that.

Position the reflector in front of your flash. How do you hold it there? You can hold it in your hand or clamp it to a

light stand. Or you can attach it directly to your camera with a glob of what we call "blue glue," which won't damage your camera. (Blue glue, originally designed to seal refrigerator gaskets, has been since marketed under many brand names as a way for parents to temporarily put up their children's art without damaging the wall.) "Blue glue" is photographer slang for a product available under several brand names in many hardware and crafts-supply stores; your store clerk may have never

heard the term, so you may have to describe it or show the picture in this book to find it.

So now we've redirected our flash off into space. Our subject now gets no light at all. How do we get that light back?

Blue Glue

Modifier 2: A big white reflector

In portraiture, there is almost always a *main* or *key* light (same thing, different words). So far, we don't have one. Now it's time to establish one. (When more than one light is used, the one the camera sees as brightest is the main light.)

In this case, our main light will be a big white board. That big white reflecting board could be the wall of your apartment. You may have that readily available, but you can't take it with you wherever you go. Another alternative is the biggest piece of foam board you can carry. (This is often called *Fome-Cor*, the original manufacturer's name; the specific brand does not matter.)

What's the biggest we can carry? Of course, that depends on our vehicle, but whatever that limitation is, we can carry a sheet double that size. Score the board with a razor blade, and then fold it in half. (Note that the scored board will last longer if we cover the other side with Mylar to make one side silver. We won't use the silver side yet, but it will certainly be useful in the future.)

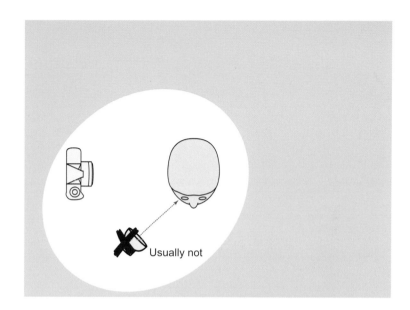

Usually not

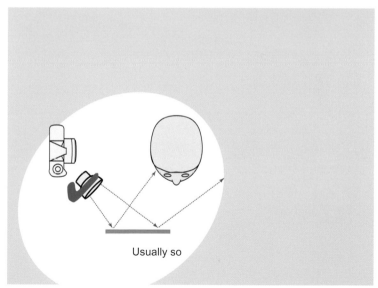

Usually so

Most modern flashes are shaped like boxes. In a diagram, it can be difficult to see how the reflection happens. Still, internally, their reflectors very closely resemble the old-time parabolic reflector.

So if the shape of the flash in the diagram doesn't look like yours, don't worry; the same thing is happening.

What is ISO?

The International Standards Association agrees on ways of measuring all sorts of things, including photographic exposure. The higher the ISO to which we set the camera (or of the film we buy) the less light required. Still, lower ISO gives us higher quality.

Why use a white reflector? Why not another silver one, like the one we are using for the flash? Silver would be brighter, and we could use a lower ISO or a smaller aperture.

All true, but a silver reflector will reflect the light like a mirror. It will look similar to whatever the original light source is. That means that a big silver reflector behaves exactly like a small one, and we don't want that. We want a fairly large light source because it is *softer*. We'll talk more about what that means in the next chapter, but for now all we need to know is that softer light is generally better for portraiture and that the *bigger* the light is, the *softer* it is.

Other modifiers: Fill light, hair light

Now we may be done with the picture. We've proven our points about the importance of the placement of the light and the size of the light. Still, if we want to do more, we can. When working with only the one tiny little light built into the camera, additional enhancements make little difference, but working with a more powerful external light can make these enhancements important. Depending on the specific picture and on personal taste, these may be things you will always do or things you will never do. Either way, you should always consider them.

Hair light may sound like a silly term for a portrait of a Sikh who always covers his hair in public, but that's what photographers usually call it. We almost never use it for bald people, but we frequently use it for everyone else. A *kicker* is almost the same thing, except it's moved a little to the side usually to light a tiny bit of the face.

We did use a hair light for this picture to try to get a little light onto the back of the black turban to separate it from the black background. However, we *didn't* use an additional flash. We used another silver reflector.

Our hair light accomplished very little in this case, but we think it's

an important "little." We think the definition of the back of the head matters a lot, but that's a judgment call. You may decide that having the back of the head disappear into darkness is just fine. We didn't think that would be just fine, because we were determined to do complete portrait lighting with only one little light built into a cheap camera. With big blond hair or with a second light, the hair light can be wonderful.

So here we are with a on-camera flash used as an off-camera main

Fill light brightens the shadows. We liked the shadow in this picture and left it as it was. Still, a different head position could have made a big difference in the lighting. As long as the man is facing the light, no fill is necessary. Had he faced the camera, though, too much of his face might have been in shadow. In that case, we would have moved the main light (the big white card) closer to the camera to light more from the front. We also might have added a second white card as a fill. We'll talk more about fill in the next photo. For this one, we're happy with the shadows.

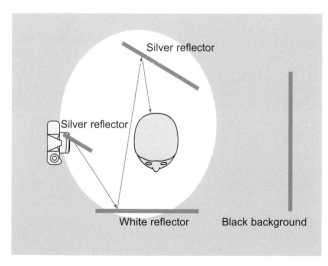

Silver reflector

Silver reflector

White reflector Black background

Don't have Mylar or foam board? Tape silver foil to a bit of cardboard for a mirror. Use a white wall or tape a white sheet (or shower curtain) to a colored wall instead of foam board. Pretty much all of us have at least one these at home already.

light, a hair light, and a hint that we're going to add a fill light in the next chapter. Is this truly a one-light portrait? Yes. And no. All of this light comes from the tiny cheap flash built into the camera. That sort of makes it a one-light picture. The rest comes from inexpensive reflectors we put in place because we knew what to put where, and that sort of makes it a multiple-light portrait.

The fact is that almost no pictures are truly lit by a single light. Even architecture and landscape photography, where even the biggest, most powerful flashes are useless—is usually made up of multiple-light pictures. The main light is the sun; the fill light is the open sky.

So we need to learn only three things: where to put the light, what size should it be, and how to make a fill.

Where to put the sun is easy. We simply need to choose the right time of day when the sun comes from whatever direction we want. (Those living in the 48 contiguous U.S. states or Hawaii have an easier job of this than do those who live in Alaska, where sunrise and sunset may happen very early or inconveniently late. Photographers in northern Greenland may have to wait months for the light to be right!)

Controlling the size of the sun, however, requires luck. On a cloudless day, the sun is a small, hard light. On a very cloudy day, the sun is a huge soft source. Usually, we want something between those extremes: just a little cloud cover, right between us and the sun to soften the light a bit, and the rest of the sky mostly clear blue, maybe with a cloud here or there just for decoration. We can't control this, and we need to see it quickly and shoot quickly when it happens. Clouds move, and the best light may be there for only a few seconds.

This means that the easiest way to learn lighting is in the studio. It doesn't matter if your "studio" happens to be your living room, your garage, or a temporarily vacant office in the building where you work. The whole advantage is to have your space where you can make mistakes, and then go back to identical conditions, make a few adjustments, and get the picture right. We learn about lighting lot faster if all the mistakes and successes are our mistakes and successes instead of the random acts of weather.

Same principle: We can control the size of the light in many ways

This photo of a little girl is also a one-flash setup. In this case, the photographer used an off-camera flash. The flash was set off by a wireless flash trigger. The photographer made his own softbox using cardboard box with tracing paper taped over an 8-by-10-inch square hole cut in a cardboard box. A second hole was cut into the back side, just big enough to put the flash in. To make the catchlights in the eyes look like they came from a four-pane window, he put two strips of black tape across the tracing paper in a cross pattern. In this case, a white foam board reflector was positioned at camera left to bounce a bit of light back into the shadows. The decision of when to add fill is an individual one—there is no one right answer. So look at your camera's image display and make decisions as you shoot. No reflector was used as a hair light because the light-colored hat retained enough detail. The softbox was about a foot away from the subject.

Haven't got a softbox and don't feel like making one? We can get the same effect using

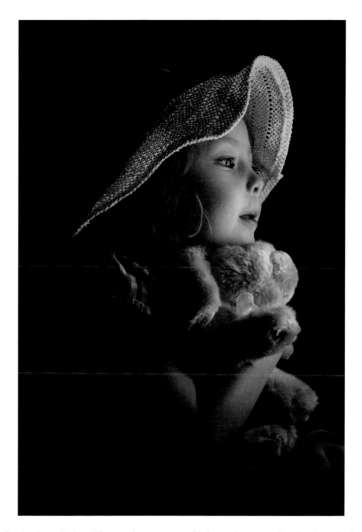

actual window light. The only problem with a real window is that we don't have immediate control over the light coming in. Unclouded sun makes a hard light, whereas both clouded sun and open sky make soft lights. The best time for the light may be the worst time for our schedule of other things we have to do.

Homemade softbox.

Haven't got white foam board? Tape white copy paper to some cardboard! Use a white wall! Don't have a wireless flash trigger? Use a small plain piece of cardboard in front of the built-in flash, angled so that *none* of its light strikes the subject but the off-camera flash is triggered by the built-in flash (which has a slave and will trigger when it sees another flash go off). Although all the tools we are mentioning are great to have (and at some point you'll get at least some), quite often there are workarounds that you already have in your possession.

The photographer also did some postproduction work in the previous picture of the girl with the teddy bear to add a bit of sepia tone and create a vignette. The color judgments are personal, but many portrait photographers vignette images regularly. This means darkening the edges of a portrait that is mostly dark or lightening the edges when the image is mostly light. It helps direct the eye to the subject and makes the edge of the image sort of fade away instead of just cutting off. The edge darkening may be obvious, or it may be so subtle no one notices. (Ansel Adams believed that practically *all* pictures needed a very slight "burn" on the edges to center the eye on the principal subject.)

Good question, but not quite the right question. The better question is how many pictures should you submit? The answer depends on for whom you are working.

We are no longer limited by the cost of film and processing (especially because hardly anyone shoots expensive 8-by-10-inch film anymore). Buying extra gigabytes of flash RAM is getting cheaper daily. We shoot as many pictures as we think we need, and then we submit as few as possible. (Keep in mind, too, that downloading and editing takes time. So although we don't have the cost of film and processing, our time counts, too.)

Consider these examples. Portrait photographers shoot as many pictures as the patience of the subject allows, and then they submit only the best for customer consideration. Notice that showing more pictures does not always increase sales. Instead, only show pictures with different moods and expression. If they are all good, people are more likely to buy one of each.

Journalistic photographers shoot as many frames as time allows, and then they submit most of the pictures to the picture editor. We don't know the final text yet and never know when our worst submission may turn out to fit the text best vertically or horizontally. Mediocre pictures sometimes win Pulitzer prizes if they appear in the right article.

Commercial photographers shoot an assignment until they get one good picture. If they shoot more, the client just may pick the bad one. Don't give the client that chance.

Developing photographers don't yet know what they do well and should shoot everything they can. Submit your best to as many forums as possible: your school, local camera clubs, websites, neighborhood art shows. Spread yourself around as much as possible; your local school or camera club guru may be great, but not the guru for you. If you haven't yet found your direction, your main job is to keep looking for it. Your own guru may be right down the hall in your school or may be running a website 8,000 miles away. Good luck!

In any shoot, try to save a few shots for experimentation. Push yourself. It will keep you fresh, and often you will surprise yourself!

Adding another light

In the photo at right, we're sort of doing the same thing we did in the photo at the beginning of this chapter on page 2, but there are some big differences. Mainly, we have a second light, and we're assuming that it will be a brighter light than the one built into the camera. What should that light be? Whatever you want, whatever you have. Light is light, and we think the simpler, the better for learners. If you have an intelligent flash, good! It will pay you back in the long run. But both your intelligent flash and your intelligent camera have already learned all they will ever know. Eventually, learn to use their particular features, but for now, try not to depend on their intelligence.

You have a better computer right inside your head. It's been built on thousands of years of research and development. Learn to use it. Furthermore, if we are just beginning to learn lighting, we will actually find a simple light much easier to learn to use than a complex one. We have enough to deal with to just learn how the light behaves. Learning the various program modes of the most sophisticated flash is a whole book

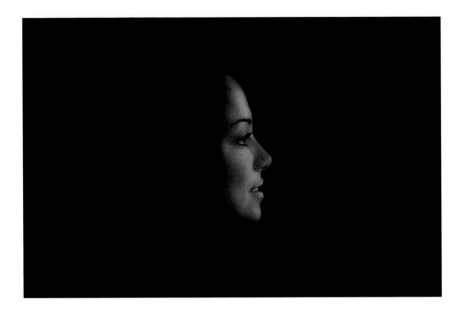

unto itself, and each model of flash requires still another book.

"Sufficient unto each day the evils thereof." We're here to learn lighting, not equipment operation. Those are two different issues. Even if we have fully mastered a particular sophisticated flash, one of the fist steps in learning lighting is to simplify the situation so that we can tell the difference between what we are thinking and what the camera-flash system is thinking.

The most important concept here is to think about the lighting. If you want to learn, turn off

every automatic feature you can, both on your flash and on your camera. (The only frequent exception is autofocus. When the camera is thinking properly, it can focus even a poor lens better than we can focus with those two even poorer lenses we have built into our heads.)

With the most sophisticated camera-flash combinations, a monkey can shoot 800 pictures and get at least one good one. Turning off the automation, we can shoot five or six pictures and get at least one good one. Don't be a monkey.

Later, turn on all the automation you please. It's good stuff for efficient working, even if it's not good for efficient learning. Some of the best photographers in the world use the most highly automated systems, but most first learned with dumb equipment.

But enough philosophy already.

In the Sikh's picture, we needed to put the white reflector in a specific spot to get the result we wanted. After all, if we put it in the wrong spot, it wouldn't have reflected the light from the built-in flash in the camera. By getting the main light off the camera, we can put it absolutely anywhere we want. In the photo on page 16, our main light is at camera right, and that's a big advantage.

What do we need to use as the main light? We certainly get the biggest bang for the buck if we use the sun. It's free, it's powerful, and it's available for at least a few hours a day almost anywhere in the world. We even have a certain amount of control over it. Want it to come from a different direction? Choose a different time of day or use a silver reflector to change its direction. Want it to be softer? Choose a day with some cloud cover. Photographers like all of these advantages, and that's why many pictures use sunlight as the main light.

Still, we don't have good control over the sun. What if we need to shoot exactly now and the sun is not in the right place? What if we want a softer light, but there is no cloud cover? What if we live in a climate where there is almost never any cloud cover?

One way or another, experienced photographers often overcome these problems, but if we're not already experienced, these difficulties will hinder our learning. It will take us a lot longer to become the experienced photographers who can deal with the problems. In fact, the complications may prevent us from ever gaining that experience at all.

So that's the problem. What's the solution? Life is short, and we want to learn as quickly as possible. After buying whatever camera we can afford, with whatever lens we can afford, the next step is buying whatever flash we can afford.

Which flash do we want? This is the hardest decision we have to make! In the long run, buying a dedicated flash built to work with our camera is probably the best decision. But right now, while we are still learning, that could be the worst decision. Why? First of all, it's likely to be an expensive decision. When we buy the dedicated flash, we're paying for the work of a lot of very smart engineers who made that flash to work with our camera. That's okay; they earned it. But those same shamefully prideful engineers sometimes build equipment that makes it impossible to operate in a fully manual mode, and we want full control!

So look carefully at the options available for the camera's dedicated flash. If it, along with

"Whatever we can afford." Having the _right_ equipment matters more than having the _best_ equipment.

the camera, offers fully manual control, we want it, and we'll be wise to spend the extra cash for the little brain in the flash. We'd like to use those automatic options later. But if we can't totally control the flash with our own hands and brains, we don't want it right now. Instead, we'll buy a dumb flash, probably with a lot more power for a lot less money. Maybe later we'll buy the intelligent flash and save ourselves some work, or maybe we'll stay with the dumb flash but buy more of them. Either way, it needs to be our decision and not the decision of engineers.

Right now, we'll use a small light. We could skip the expense and do the same thing with the sun, but for now we want to talk about your light source. First, we'll assume you've bought a small light to increase control. If you haven't done that, you can still use the sun.

Let's look at the photo on page 16 again. We already know it's a good photo. How did we get there?

The photo at right is essentially the same photo, but it sure doesn't look the same. Why not? Well, for a start, we've taken one

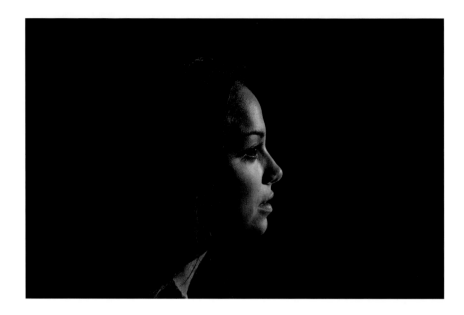

of the most beautiful women we've ever seen and turned her into a hag. Pretty women have smooth skin, but look at the skin texture in this picture. It's rough and wrinkled, even though she's very young. That's not her fault; it's ours. What did we do wrong?

The whole problem is the size of our light. Small lights make hard shadows; big lights make soft shadows. It's as simple as that. Neither is inherently better than the other, but we have to think about which we want and make that decision again for each picture. If we've bought a small

Old women and old men are beautiful, too! We'll get to that soon.

flash, we already have a small light. So getting the hard shadow is easy. Now we have to turn that small light into a big one. Once we learn how to obtain both, we

can also get anything in between: a medium-size light of whatever size we want.

To get from the harsh, unflattering image on page 18 to the improved light in the photo on page 16, we put a large sheet of translucent white diffusion material between our subject and the flash. Voilà! What is diffusion material? Many things: cloudy sky, thin white paper or plastic, foggy or smoky air. All of these can turn a small light into a bigger one. The distance between the light source and the diffusion also affects the effective size of the light: the farther away, the bigger the light. *Notice that this is exactly the opposite of the effect of moving an undiffused light farther away!* Moving an undiffused light farther away makes it a smaller light: think of the unclouded sun, 93 million miles away. Moving a small light far enough away to fully light a large diffusion material evenly makes it softer.

Try putting your small flash directly against a white shower curtain. (We'll talk about white shower curtains a few times, because it's the largest piece of diffusion material many people have where they live.) Take a picture of almost anything, move the light as far

Translucent? Transparent? What's the difference? Both words describe material that lets light through, and many people use them interchangeably. They mean different things, though, and photographers talking to each other have to get the terms right.

Transparency allows an image to pass through. Our neighbor's cat looks like a cat through a clear glass window. But if the same window fogs or ices because of weather, we still see light coming through but no identifiable cat. That's translucency.

from the curtain as possible, and then shoot another picture of the same subject without moving the camera. (You may or may not need to adjust exposure.) If you don't already understand the difference the effective size of the light makes, you will see it here and never forget.

A large light is the kindest light for faces. We also added some

neutral density filter in front of the built-in flash because its lowest power setting was too much. By diffusing our lights (thus enlarging them), we still got an image with the drama provided by shadows, but we've eliminated the ugliness of harsh lighting (the bane of small lights).

All that said, we may not always want the kindest light. If we shoot for a newspaper, the paper may not always want the kindest light if the subject is an oppressive dictator or a vicious criminal. Even good-hearted people may not want the most flattering portrait if they happen to be avant-garde artists or suffering saints.

Diffusion and neutral density material comes in a variety of densities. We don't need them all. Get a lighter and medium density of each to start. We can always stack them together in layers if we need either more diffusion or more dimming of the built-in flash.

So we've got one basic profile done three different ways. If we find ourselves with great window light, use it. If not, with these simple tools, we've still got options.

Now let's look at the simple tools that make this possible.

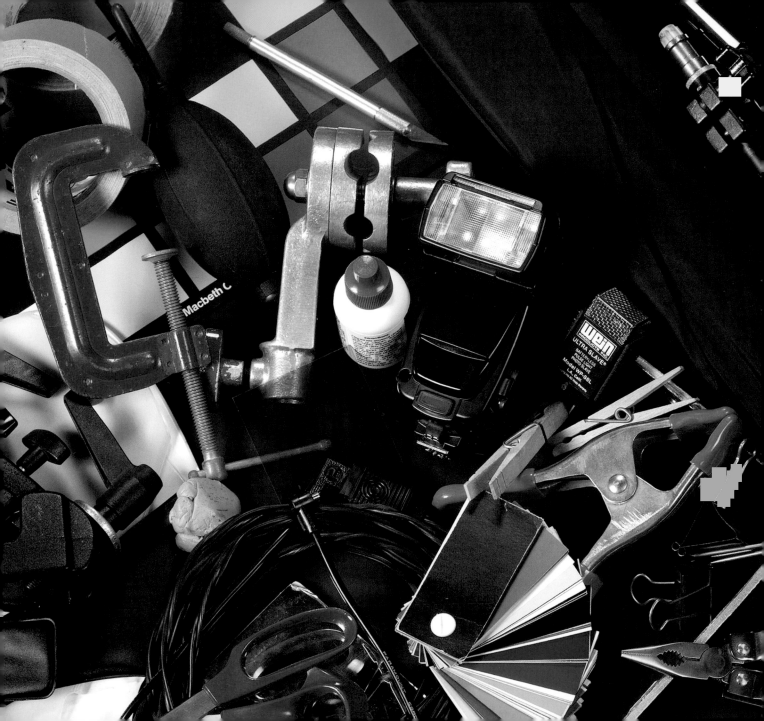

Chapter 2: Tools: Now We Have Light, but How Do We Get It Under Control?

A GOOD ONLINE photographic store will have several *thousand* tools, and these sources aren't the only choice. Theatrical supply stores have even more. Still, we've already proved that we can make a good portrait with only one tiny light and some homemade tools. Nevertheless, we need to at least put forth a list of equipment and tools that each photographer should be aware of. As your experience grows, you can pick and choose from these additional items. We're not suggesting that you run out and buy everything described in this book. In fact, we recommend you stay minimalist at this point. *If you find yourself thinking you've got to have* *something that you can't make yourself, try renting or borrowing it first.* All too many photographers have bought something blindly, only to have it gather dust. Experiment with homemade or borrowed tools first.

Know that these tools are available. Over the long term, having a selection will enable you to work more efficiently and easily. (And the faster we work, the more we can charge!) Throughout we'll mention options for making many of these tools yourself for pennies (such as the softbox and mirror described in Chapter 1).

Don't be intimidated by the list. Learn what's available, and then pick and choose.

There are various ways to get things done in photography. The tools here give us options. Start simply and when possible with homemade versions. Only upgrade to manufactured versions when you find yourself having to remake an item often because you use it so much.

Off-camera flash

We've proved that we can make a good portrait with only one tiny light on the camera. If that's all we have, keep that light and keep working. Still, working with so little is difficult, and we'd like to have at least one more light.

The easiest way to get another light is to use the sun. Let that be your main light and use your on-camera flash as fill. For us, though, that's not the easiest way to teach lighting. The sun is too difficult to control. It may be extremely "hard" for one reader, but with enough cloud cover, it may be extremely "soft" for another reader in a different place in the world on the same day. We can depend on the sun for energy for a bazillion years to come, but we can't depend on it for photographic lighting from one minute to the next. With so many random things happening with sunlight, a novice photographer has no idea what lighting changes he or she has made versus what changes the weather has made. Ignorance is guaranteed; both of your co-authors, Fil and Robin, have been there, done that.

So we want you to get one more light beyond what your camera offers. What sort of light? Almost anything, as long as it's your light and you can control it with your own hands, eyes, and brain. A 60-watt desk lamp will be fine for many subjects. An "intelligent" flash is better, but a "dumb" flash is perfectly adequate.

Money always matters, no matter what we can afford. A photographer who can only buy a $50 flash inevitably wants a $100 flash. Another who can afford $20,000 worth of studio strobes always wants to have $40,000 worth of lights. We all do what we can with whatever we have.

Think seriously about whether you want an intelligent or a dumb flash. You'll base that decision mostly on what you want to photograph. If you're one of the paparazzi and need to shoot quickly before the celebrity disappears into a building where you're not allowed, you definitely want the intelligent flash. You don't have time to think about flash power settings unless you are very experienced. The flash, along with your intelligent camera, will sometimes get the exposure wrong. But if you spend even an extra two seconds figuring out the right exposure with fully manual equipment, it may be too late to get any picture at all.

If you like still life, though, a bowl of fruit or a glass of wine will sit for a pretty long time without changing appearance. (Some of Edward Weston's pepper photographs, without flash, required up to 12 hours of exposure time.) People who want to do this sort of thing can buy a dumb flash with way more power for a lot lower price.

If you are a novice photographer, you may not yet know what you most want to do. In that case, buy the least expensive intelligent flash you can. Experiment. Save your major investment for later.

Whatever light we use, it's important that we be able to fully control the camera *and the light on the camera*. All cameras can be set to a "Manual" (read "dumb") mode, and that's good. However, many of them will still revert to some sort of automatic (read "really stupid") mode when we use the popup flash along with a second external flash. That takes control out of our hands, and we don't want that.

We all want the most intelligent camera and flash combination we can get but that can be set to fully manual operation when we need it.

Although there is plenty we can do with just the sun and the built-in flash, the benefit of an off-camera flash is its mobility. We can place it anywhere we want.

In some cases, we will just put this additional flash right on the camera's hot shoe. It's pretty much where the built-in flash is,

but it has more power and it's a bit bigger than the built-in flash. This *can* be a good thing to do, in specific situations:

1. We are shooting a quick-moving event—news, weddings, locker-room sports celebrations—where there is simply no time to put the light someplace else.

2. We are using "beauty lighting" for as little shadow as possible. (But in this case we would still like to use a bigger light.)

3. We are shooting small-scale scientific and medical photography. (But then we often want the light to be a *ring light* around the lens instead of a light on top of the camera.)

4. The light on the camera is a *fill* light to illuminate shadows cast by the *main* light. How do we combine these two?

For people learning lighting, number 4 is the important one to most of us. We don't always need a fill light. This book's cover was done without one. Still, in most cases most photographers will want one. Fortunately, the fill light is usually there already: the flash built into our camera. Along with that, we almost always have a second light. It may be free sunlight provided by nature, it may be a studio strobe worth more than the mortgage on our house, or, most likely, it may be something in between. It makes good sense to put that light to work doing something beyond what our built-in flash can do with ease.

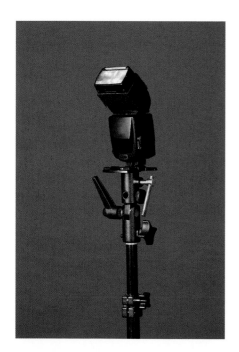

Off-camera flash on a light stand. You don't need the newest flash on the market. Consider buying used equipment to start.

How to trigger flash

If the flash is not mounted on the camera, we need a way to trigger it remotely. Other than the hit-or-miss method of having an assistant fire the flash as we shoot, there are several good ways to do this. The *best* way depends on what we are shooting and where and, always, budget. Ideally, balancing real need and real money, we each decide what's best for us.

Synch cord

This is certainly the least expensive and often the most reliable tool for the job. In most cases, there's an electrical connector on the camera and another one on the flash intended for this use. Exactly how those connectors are shaped varies, though, and we have to get the right cord to mate with the camera and the flash at each end.

Long synch cords may be expensive. If we want the flash to be a greater distance from the camera, one of the more "expensive" synch methods may actually cost less than the "cheap" synch cord. Still, we don't always need a synch cord to cover the whole distance. We can use a

short synch cord where one end matches the camera and the other fits an ordinary household extension cord. At the other end, we have another synch cord that mates the household cord to the flash. This gives us longer-distance triggering for fairly low cost. Until very recent times, almost all photographers

used synch cords at least much of the time. They have two big disadvantages, though:

Disadvantage 1. We can safely use a synch cord to trigger *only one* remote flash. Mechanical cameras had very lightweight electrical switches, able to survive only very low electrical current, for

the sake of rapid, accurate movement; today's cameras follow similar standards. Plugging together a make-shift arrangement of cables to trigger multiple flash units *can burn the electrical circuits in the best-built camera!* If we want more than one remote flash, we have to trigger them without wires.

Disadvantage 2. A *simple* synch cord *only* triggers the flash. There can be no intelligent communication between the smart flash and the smart camera. That's fine for now, because we want you to do as much of the thinking as possible. Later, though, you will probably want to make use of some or all of your equipment's intelligence, and synch cords that can transmit the extra data tend to be short and expensive. Because the whole point of using the synch cord is to save money, we may undo its sole advantage this way.

Light-sensitive trigger

We plug one of these into the remote flash. It sees the light from an on-camera flash and nearly instantly triggers the flash it's plugged into. Some of these actually cost less than many synch cords, and we can plug them into literally any number of flashes without any risk of damaging our camera electronics. Many studio strobes have these already built in, and we have nothing extra to buy.

An inexpensive trigger.

This trigger can be plugged in two ways, possibly reversing its positive and negative electrical terminals. We tested it at a distance where it would _barely_ work at all. Then we painted a red dot on the trigger and the flash to mark the position where it works best.

A more sensitive (and more costly) trigger.

Sounds like a good solution, and it can be! Still, we need to know about disadvantages, here, too.

Disadvantage 1. Lack of sensitivity. This may not be a disadvantage at all if we work indoors at fairly small distances. However, if we photograph a large group in bright sunlight, the trigger may not see the camera flash and may do nothing. We can easily solve this problem by buying more sensitive triggers, but the increased cost may undo any economic advantage over other triggers. A good compromise, used in the past by both Robin and Fil,

This trigger will work at a greater distance, even in bright sunlight.

can be to buy one expensive trigger for the most distant light and a handful of cheap triggers for the lights closer to the camera.

Disadvantage 2. These respond to *any* flash they see. Any other photographer present may trigger our flash. Our flash may be in the middle of a recycle exactly when we need it most. Most photographers tend to cooperate in this situation and time their shooting to give the other guy a chance at the shot, but this compromise is not ideal for anyone and can result in complete disaster for everyone when competitors refuse to cooperate.

Infrared trigger

Technically, we could simply consider these to be a special type of light-sensitive trigger, as infrared is simply another frequency of light that happens to be invisible to humans. The similarity ends there, though: most infrared triggers are highly intelligent. They allow both the camera and the flash to measure the scene, think about what each sees from its viewpoint, and agree with each other about what the camera is going to do and what the light is going to do. These are expensive, but some of the cost is reduced by not having to buy a separate device. The system may be ideal for (1) absolute novice photographers who want as much automation as possible so they don't have to spend a lot of study time and (2) highly experienced photographers who want the system to take over a lot of the

The infrared trigger on this flash not only triggers the flash, but it can communicate intelligently with the camera for remote power adjustment.

routine thinking, but know when to override the automation to get a better picture. The fact that you are taking the time to read this book probably means that you fit neither of these categories.

Disadvantage 1. These triggers tend to be brand specific. If we want one maker's camera and another maker's flash, they may speak different languages. The extra cost is wasted.

Disadvantage 2. These often provide only short-range communication. Sometimes the best of the dumb visible light triggers will work over greater range.

Radio trigger

These triggers require a transmitter on the camera and another on the light. They allow remote control of a specific brand of flash by another maker's camera. Some models of this equipment also allow remote control not only of lights but also of a second camera! Depending on the brand, they often allow remote control over much greater distance than other synch systems.

Disadvantage. Cost.

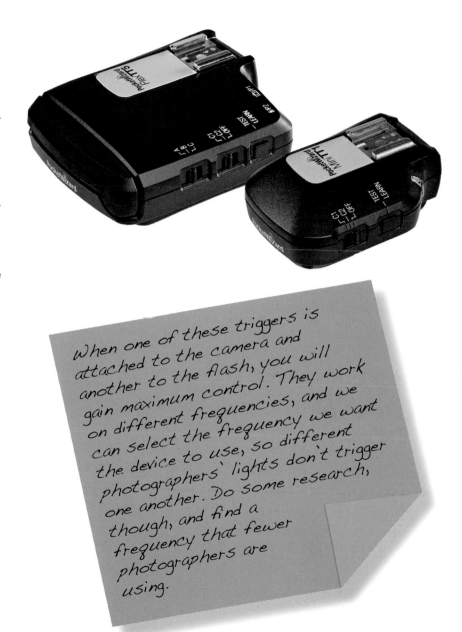

When one of these triggers is attached to the camera and another to the flash, you will gain maximum control. They work on different frequencies, and we can select the frequency we want the device to use, so different photographers' lights don't trigger one another. Do some research, though, and find a frequency that fewer photographers are using.

The size of the light

The size of the light may be the most important decision we make. More often than not, we'll want a large one. The easiest way to get a bigger light is simply to buy a bigger light. We could close our case right there, except this is not practical for most people. Beginning photographers don't want to pay the cost. Experienced photographers generally want the flexibility of taking the light to another location with as few assistants as possible. So we usually want to make a small light behave as if it were a bigger one. There are several basic ways to do this, and we'll want to use them all.

Bounce is our principal tool. Instead of aiming the light directly at our subject, we aim it at a bigger white surface and let that surface be our main light. What might that surface be? Anything big and (usually) white. If we have a white wall or ceiling handy, we're in fat city. Little work, good lighting.

We can bounce the light from anything handy. What's handy? The following two situations are most common:

> *Wall bounce.* If we are using *only* the light built into the

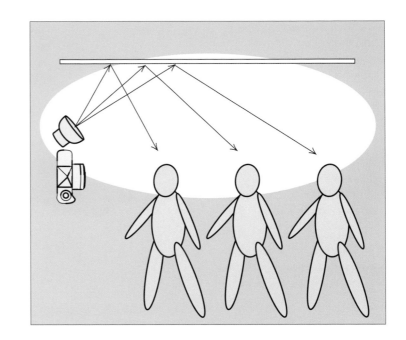

This light is bounced from the white ceiling. We could just as easily bounce it from a white wall or a white bed sheet taped to the wall.

camera, we can use a silver reflector to direct it to a nearby wall. Better lights, attached to the camera, often allow swiveling to point them in another direction. Still, we can't use just any wall that happens to be handy; the wall needs to be close to white. What is "close to white"? That depends on how good your camera is at automatic color adjustment or on how carefully you adjust the color balance. Automatic color balance is amazingly good right now and is likely to be even better in the cameras available by the time you read this book. Manual balance can compensate for a very wide range of degrees Kelvin.

This only works, however, if the wall is "nearly white." It also only works with a single light. If we use a second light bouncing from a beige wall, plus the camera's built-in light for fill, there's no way to adjust for both colors at once.

The same is true if the sun is our main light. Our on-camera flash approximates the same color as midday sunlight, but if we shoot near dawn, at dusk, or on a cloudy day, the colors of the two lights can be dramatically different. We'll talk more about this later.

Ceiling bounce. Most ceilings are white. Bouncing a flash off the ceiling generally gives us pretty accurate color. Still, if the ceiling bounce is our only light, we may get very dark shadows under the eyes, especially if we are very close to the subject. (American photographers often call this "raccoon eyes.")

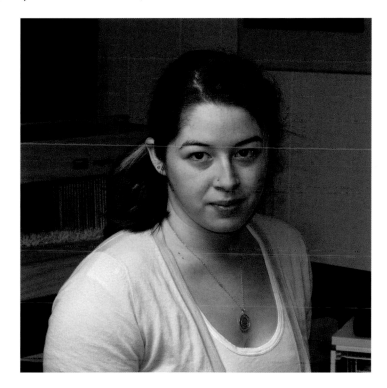

"Raccoon eyes"—most people don't find this flattering.

We need to know about this defect to keep it from happening. The good news is that it is easy to deal with. The flash we bounce off the ceiling is almost always an external light. We still have that built-in flash on our camera to illuminate those shadows, or we can use a fill card. The next picture is the more likely event: a ceiling bounce external light plus, in this case, a white fill card.

This is not exciting lighting. It won't win us any awards unless the subject is an interesting person and the background is enticing. Still, it's a good, basic arrangement that allows a novice photographer to get a competent picture. It's also a quick lighting style that plenty of highly experienced photographers use to meet a deadline.

In fact, wall and ceiling bounce works so well that some photographers can stop reading this chapter right now. Skip on to the next chapter. You may already know all you need here. Most photographers who buy books, though, want to do more. So keep reading.

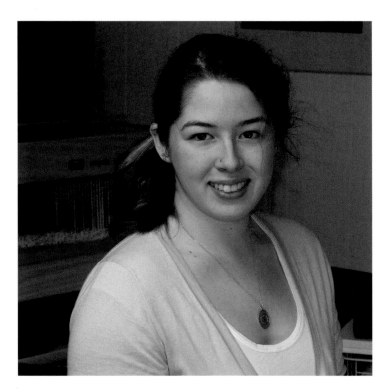

Wall Bounce

But what if we don't have a wall or a ceiling to use for bounce?

Maybe we're outdoors and there is no wall or ceiling. Maybe we're photographing the designer of a newly successful microprocessor in the newly built manufacturing facility where the ceiling is 14 feet high (and maybe painted black) and the nearest wall is 30 feet away. Don't discount this possibility, even if you are the mailroom clerk. If you are a good amateur photographer, your employer may say, "Why bring in a $2,000 professional when we have Sally right here?"

This happens. In those cases we have to bring our own bounce reflector. There are many ways to do this, but the three common ones are a big bounce card, an umbrella, and a collapsible ring

reflector. By far, most photographers choose the umbrella. Still, we'll talk about the bounce card first, partly because it resembles the walls and ceilings we've already discussed, but mostly because it is the cheapest.

The big bounce card

We want the biggest card we can carry. What "biggest" means to you will depend on whether you drive a truck, ride the subway, or do something in between. We'll talk about a 4-by-8-foot card. Scale it up if you can carry it; scale it down to whatever size you can accommodate. Also consider what you want to photograph.

For the first material, overwhelmingly, we recommend Fome-Cor. That's the original name, but other manufacturers sell it under different names. Generically,

it's foam board: plastic foam sandwiched between two sheets of paper. Most makers sell two different degrees of hardness. The harder version is better for purposes like building trade-show signage, but the less expensive softer version is good enough for a photographic reflector.

For the second material, we recommend silver Mylar (a DuPont name). Cover one side of the foam core board with this mirror plastic. We can buy it in two versions: with and without an adhesive back. The adhesive back version costs more, but the ease of application is well worth the price. Whatever version you find, practice attaching a small piece smoothly to a board before you assemble the big one.

We can lean foam board against something (a chair, a wall, a ladder, a book) and clamp it to an angle iron or light stand in order to place it where we want it. By scoring it, it folds for easier transport. With Mylar on one side, we get two reflectors in one.

Of all the tools, this is one of the cheapest and it's incredibly useful.

Having the foam board white on one side and silver on the other allows us to switch it back and forth. Sometimes we want the silver side, sometimes the white side. As we mentioned earlier, that's not the only advantage of the Mylar, though. The Mylar is extremely tough stuff. Score the board with a razor blade or a sharp knife on the white side. Make the score exactly in the center and use a metal straight-edge to guide the cut. Then bend the board in half.

Now we can store the reflector in half the space and carry it in a vehicle half us big. The silver Mylar that holds the board together will bend and unbend essentially forever. We suspect that archeologists unearthing our civilization centuries from now will find photographers' bounce cards, dirty but intact.

The umbrella

The big bounce card, along with a few smaller ones, is the most useful and cheapest reflector a photographer can have, but it certainly is not always the most practical to store or to carry. If we can spend a little more money, we certainly also want an umbrella.

We don't think anyone knows which photographer first thought of this idea. Almost certainly he used an ordinary white umbrella designed to keep rain off peoples' heads, plus some sort of jerry-rigged arrangement of clamps and tape to hold the

umbrella, the light, and a light stand together. Today we have several umbrella designs made specifically for photography. A well-equipped professional photographer will have at least one of each design, possibly in several sizes. A serious amateur

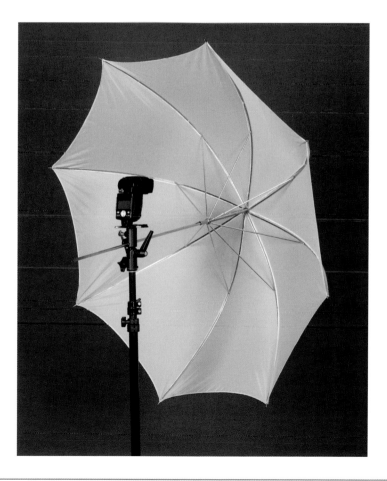

needs to consider buying *one* of whatever design seems most often useful.

A *white umbrella* is the least expensive and also most versatile version, because we can use it two ways. We can use it as either a reflector or a diffuser. We'll talk about diffusion later, so for now we'll look at the umbrella simply as a reflector.

As a reflector, the umbrella behaves exactly like our big bounce card, *but with one important exception*. If we are shooting a portrait, the reflection from human skin will be identical whether we use a bounce card or an umbrella. However, if we photograph a mirror-like subject—glass or bright metal—the shape of the light will be apparent in the reflection. In those cases an umbrella-shaped reflection can be quite ugly and we don't want it. (We do get the same ugly reflection in a portrait: the highlight in the eyes. But those reflections are so small that usually no one notices.)

A *silver umbrella* reflects more light than a white one. It also provides less diffusion, so we may need to buy a bigger one to get the same effect. (Remember, the bigger the light, the softer the shadow.) Still, buying a bigger umbrella is less expensive than buying a brighter light.

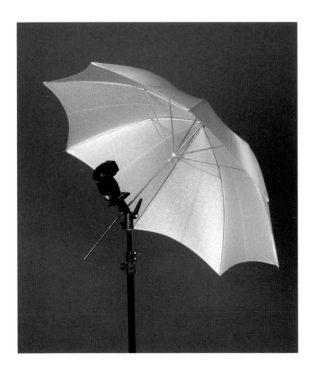
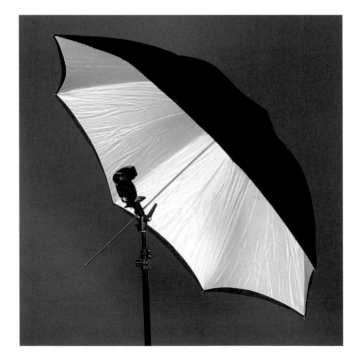

A *black-backed umbrella* is sometimes useful when we work in tight spaces. These umbrellas may be white or silver on the inside, but the outside is covered by a second layer of black cloth. This keeps light from going through the umbrella and reflecting from walls and other surfaces. The black cloth is easily removable if we want those additional reflections. This is the best umbrella to have, but it is also the most expensive. Few amateurs will find it worth the cost. Still, it's good to know about, because we can improvise the same effect with a piece of black cloth paper clipped to the back of our white umbrella.

The circular reflector

The *circular reflector* has a piece of silvered cloth stretched over a plastic frame. The plastic frame can be twisted into a figure-8 and then folded to half its original diameter. This reflector also comes with a carrying case. So what's its advantage over the silver foam-core reflector we already know how to make and much less expensively?

The advantage is more stability in wind. Cloth allows some air to blow through it; paper and plastic blow over to the ground more easily.

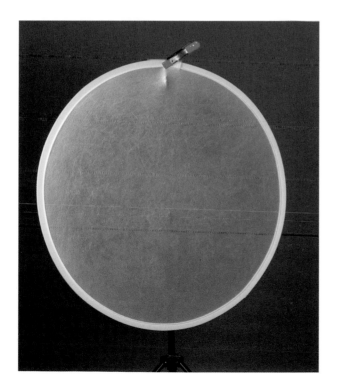

Folded circular reflector.

Softbox

Softboxes are boxes with diffusion material in front and attach to a light source. Sometimes there is additional diffusion material (baffle) inside. They create beautiful soft light. They come in a wide range of sizes. Most professional softboxes disassemble for easy transport from location to location. Their costs vary by manufacturer and size, but we saw in Chapter 1 that we can make one ourselves out of a cardboard box, cutting holes for the flash to fit in and a hole on the front to which we can tape tracing paper.

There are also a variety of small diffusers that attach with Velcro to a flash; these act like softboxes but are very portable. Regardless of which type you use, the larger the diffuser, the larger the light.

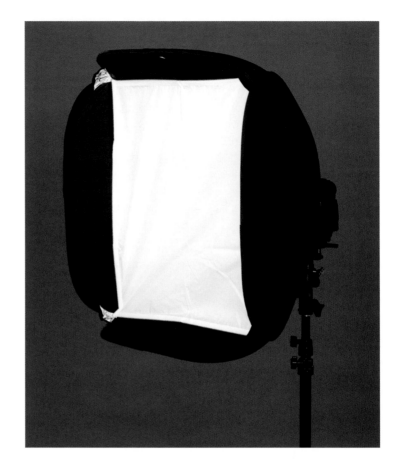

Medium manufactured softbox.

Small manufactured softbox.

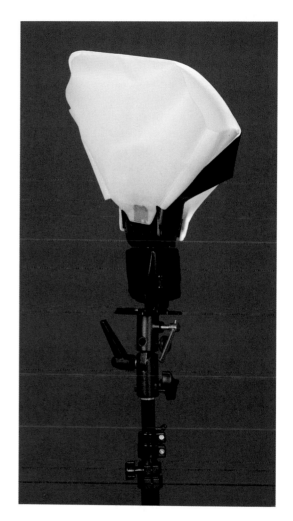

A small diffuser on a flash that bounces light.

Diffusion

The other way to make a light bigger is to use *diffusion*. This means putting the light through a big piece of translucent material. How big? Well, pretty small if we're photographing a flower or insect specimen. But makers of major motion pictures with big budgets sometimes hang huge diffusion material from the top of one building to another, diffusing the light over a whole block, to get the picture. We'll assume that you cannot spend thousands of dollars to make a photograph.

So what do we use for diffusion material? A white shower curtain bought at a discount store works just fine. We can cut it into smaller pieces, and we can buy another one whenever we need it. But what do we do if we need it on a day when the discount store is only selling flower-patterned shower curtains?

A better solution is diffusion material made specifically for photography. They're called *gels*, because they used to be made of gelatin, and they are available in a very wide range of transparent colors in addition to the white diffusion material. It's best if you can buy this item from a brick-and-mortar store, because with the wide variety of densities available, you'll want to look at them before you buy. You may also be able to get a sample booklet of any manufacturer's complete selection of filters, but retailers are generally willing to give them only to their bigger and more regular customers. Try asking for a gel sample pack at the same time you are buying a particularly expensive item.

Roscoe sample pack opened to diffusion material.

Many photographers use these "samples" as working filters on small lights, never buying the larger gels at all! Roscoe has wised up to the fact that they were giving away free usable merchandise and started selling the *Strobist* sample pack. It only contains a few colors, including translucent white, but it includes the colors most photographers are likely to use. Is this an improvement, to be able to buy something we used to get for free? Absolutely! Now everyone, not just the big spenders, can have a sample pack for a very affordable price. By the time you read this, we hope other makers beside Roscoe see the wisdom of selling their gels this way.

Unlike standard sample packs, the Strobist pack (and presumably some future non-Roscoe products) also includes multiple copies of each of the colors photographers are most likely to use, so that we can put the same gel on multiple flashes or replace a dirty one on a single flash. The only trouble is that these fit only small flashes; still, they allow us to see how each gel works and we can always buy bigger sheets and often big rolls of the single colors we find most useful.

Roscolux colored gels. Handy for changing or intensifying the color of backgrounds or subjects in a photo.

For this book, the translucent white filter is the one we'll probably discuss the most, but having some neutral density filters on hand is also a good idea. They come in a variety of densities. They are useful when one of your lights is too strong and you either can't or don't want to move it farther away. The joy of these filters is that their impact on the color is minimal. For many of the images in this book, the popup flash was too strong, so we put a neutral density filter in front of it. If we've only got the weakest density of this filter, we can always fold it up as many times as our piece will allow and still cover the flash, until we get the amount of light we want.

So now we have some sort of diffusion material. How do we put it in front of the light? Obviously we can just tape it to the light, but that's often not good enough: we still have just a small flash and the whole point is to get a bigger light. We need to get the diffusion a significant distance out in front of the flash so that the bigger diffusion material becomes the effective light source.

If we have a big enough piece of diffusion material, we can

BECOME A STROBIST

Speaking of Strobist, that's David Hobby's brand name for his philosophy of lighting, and anyone reading this book should look up *Strobist* online. Using a combination of a free website, personal seminars for a fee, and a video series for people who cannot attend the seminars, David may be the most influential lighting teacher in the world. Some people learn better from books, some online, and some in classrooms, but most people learn better with *all* of these. David has promised not to write a book, so he doesn't compete with us, and we are happy to recommend him!

tape it to a doorway and put the light outside the room. We can also tape it to a window and let the sun be our main light. Both of these are good ideas, and if you are a hobbyist, you should certainly try them; they may be all you ever need.

So how do we hold the diffusion material a few inches or a few feet away from the light? That depends on whether we have more friends or more money. We can simply ask a friend to hold

THERE'S TAPE AND THEN THERE'S GAFFER TAPE

Duct tape, available from hardware stores, is strong and will hold a diffuser in place for years. However, we want to take that diffuser down after a shoot, and duct tape often damages the surface. Masking tape, with a weaker hold, is much less likely to damage.

Gaffer tape offers good hold with much less possibility of damage and is available from good photographic suppliers. Gaffer tapes differ. If you don't like the first one you buy, try another brand. We have attached things to historically important walls while curators gasped in horror and then removed the tape without damage.

Gaffer tape is more expensive than other tapes, so keep duct tape and masking tape in your kit, and use those when it's safe to do so.

the diffusion material a distance from the light, or we can buy other equipment to hold the diffuser. (All too often, people with more money also have more friends, but that's a social issue we'll avoid in a technical book!)

Don't overlook the possibility of human hands holding the diffuser, especially if you've joined a local camera club where members are eager to help each other to make good pictures. Still we'll assume the worst-case (or sometimes the best-case) scenario in which you either don't have friends to help or you're a professional photographer who needs to pay assistants. In those two cases, buying or making some more equipment makes sense. The extra equipment is also more reliable: it stays where we want it; humans move around.

Framed diffusers

Sometimes we find ourselves using the same size and shape diffusion over and over again. In this case, it might make sense to already have a *framed diffuser* of the size and shape we want. We can buy these, but they require almost no skill to make, and doing it ourselves makes good sense. Screwing together a few pieces of wood and taping on a piece of diffusion material is something almost anyone can do.

A diffuser scatters so much light in so many different directions that we almost always also want a

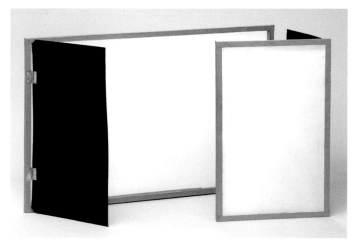

gobo to block some of that light. (A gobo isn't a diffuser, so we won't talk about it much here, but we'll say more later.) If we work mostly in our own space and usually don't have to worry about transporting bulky things, it makes sense to permanently attach a black card to the framed diffuser with inexpensive hinges. That's what we've done in the diagram at right. On a tabletop, the gobo also serves as the support for the diffusion. Without a table, the whole assembly can be clamped to a light stand. Inexpensive light stands work fine: if the thing falls over, we're not damaging an expensive light. Cheap hardware store spring clamps also work; we don't need photographic specialty clamps.

Things get a lot more difficult when we leave the studio, though. Just one of these framed diffusers can be pretty bulky to carry. On location we'd usually rather have a collapsible umbrella. Umbrellas don't work well, though, if the subject is highly reflective—metal, glass, glossy plastic. The shape of the umbrella reflection in the subject is so pronounced that it distracts from the subject itself. In those cases, we need to make the

diffusion panel *after* we get to the location. One good way to do this is with inexpensive plastic plumbing pipe. We cut it in advance to the lengths we think we need and put it together on the scene with plastic elbows made of the same material. Plumbers have to glue those joints together for a watertight seal, but we don't have to worry about that. The frame will hold together just fine with no adhesive and come apart easily when we are ready to leave. We

carry our diffusion material in a roll and tape it to the frame.

The umbrella

But wait! We've already talked about this, haven't we? Yes, but not enough. The umbrella can either be a reflector or a diffuser. So far, we've only used it as a reflector. Now we'll use it as a diffuser. If you like this technique, the good news is that only the cheapest plain white umbrellas work well this way.

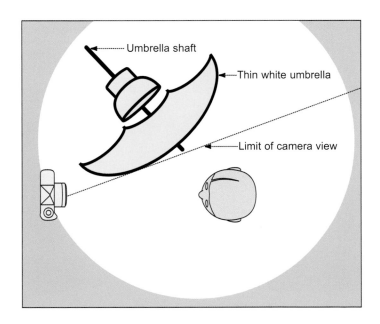

Why would we want to do this, when the umbrella works so well as a reflector instead of a diffuser? The reason is that the closer the light is to the subject, the bigger it effectively becomes. We can't move the reflective umbrella as close to the subject, because the camera begins to see the shaft of the umbrella. If we move it even closer, the camera can see the flash itself. *And after all this, our primary light source—which is the umbrella, not the flash—may still not be close enough to our subject.* Remember that the closer the light is to the subject, the bigger it effectively becomes. We can use the diffusion umbrella much closer to our subject. We can use smaller equipment, carry it more easily, and spend less money more effectively if we use the shoot-through technique.

The bad news is that if the lighting assembly is in a small space, the shoot-through technique is going to cause a lot of additional reflection from nearby walls. If we don't want this additional reflection, we have to drape the entire backside of the lighting assembly with something black to avoid the additional reflection. The better

Large lights are not always the best lights! Still, if we have only a small light but learn how to turn it into a big one, then we can do anything!

news is that most of the time we will be happy to have this additional fill, accept the picture as is, and shoot it with no further modification.

Light blockers

Almost everything we've talked about so far tends to spread the light around. That's not always good; some things and some areas need to be kept dark. The most practical way to do this is with black paper and cardboard.

Adjustable flash coverage

Many of us already have a flash that adjusts to the angle the lens sees. If we have full manual control, we may be able to set the flash for a long lens (narrow angle of coverage) and then actually use a much shorter lens. This gives the flash a slight spotlight effect.

The gobo

The *gobo* is a black card that *go*es *be*tween the light and anything else we don't want to light. We can use gobos with any level of sophistication we want. Lone photographers often handhold a gobo in front of their light as far as their arms can reach. Hollywood directors of lighting (DLs or LDs), with bigger budgets, attach the gobo to a separate stand (and use a half-dozen names for different sizes and shapes of gobos).

Black card gobo.

Don't think of a gobo as *just* blocking the light from the *subject*. A simple black card can also be used as a gobo to keep unwanted light from hitting our lens. Because we can precisely position the gobo, it's *much* more effective than a fixed lens hood!

More sophisticated gobos with holes can create moody lighting. With a little patience and a sharp knife, you can make your own. Gobos with holes are called *cookies* (short for *cucoloris*, with several spelling variations). The photo below shows a homemade gobo, which makes the light from the flash appear to be sunlight streaming through window blinds. The photo on the next page at left is a commercially made wooden gobo to simulate, say, light passing through tree leaves. Certainly it's sturdier than the cardboard version, but you can make something similar yourself and spend your extra money on other photographic equipment.

The photo at right on page 50 shows a slatted homemade cardboard gobo in use. Depending on the angle and the intensity of the light passing through the gobo, it can look like light coming through a window with blinds or can simply create an interesting pattern on a background. In this case, the gobo was clamped in place on a stand. The studio was darkened because the background was lit with a continuous tungsten light source. This light isn't very bright, so a long exposure was needed. (How long an exposure? This one was 2 seconds. But the determination comes from how strong the continuous light source is and how bright we want the background to be.) A flash was positioned slightly off-axis camera right in a medium-sized softbox. The flash was used to light the man. Even though this was a long exposure, the man is sharp because he was lit only by the flash.

Homemade cardboard cookie. This would create the effect of light coming through window blinds.

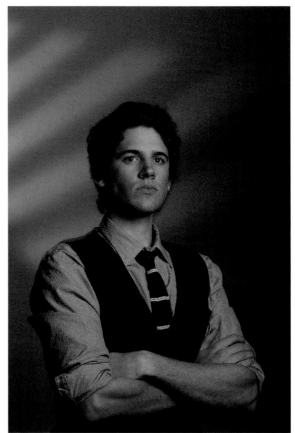

A commercially produced wooden
cookie. We can easily make this
with cardboard as well.

Barn doors

A *barn door* is a special type of gobo that attaches directly to the light; we need no additional stands or hands to support these devices. Barn doors swing open and closed to control the spread of the beam. This sounds like a good idea until we realize that there's no way to move a barn door closer or farther from the light, and that's a big loss of control. Sometimes, though, we don't need precise control. Then we prefer the barn door because it is the simplest and least cumbersome way to block light.

We can make a barn door simply by taping a black card to the flash and bending it as much as we need to restrict the beam. If we find ourselves using barn doors frequently, then we buy a commercially manufactured barn door that has better durability and precision. Usually, one barn door is enough, but for uses such as background lights, we may put them on all four sides of the flash.

Snoots and grids

Snoots and *grids* go over lights with the purpose of restricting the light's spread. Using these can be a huge step for a novice

In this case, we just have one door, but there are times when we will have four.

who wants more dramatic lighting. As with the barn door, we can make snoots and grids for pennies. Only if you find yourself using them over and over might you consider buying one. (Also, know that we *must* have a commercially manufactured metal grid and probably an auxiliary fan for studio strobes to avoid overheating.) The photo on the following page shows the basic supplies we used, which not everyone will have on hand: cardboard, straws, and tape. We'll also need scissors, a ruler, and pretty much

any glue—all of which we already have. We can measure each side of the flash or we can wrap a piece of paper around the flash, pressing so that we can see where the edges are.

Making a grid

Cut a piece of cardboard to go around your flash, adding about ⅜ inch to create a flap, which you'll eventually use to seal the ends together. It should be about 3¼ inches deep, enough to hold a handful of short soda straws plus an empty section to slip over the flash. Score the cardboard lightly to help it bend around a rectangular flash. Cut the straws into ½- to ¾-inch lengths. This doesn't mean the straws should be different lengths—they should all be the same—but you may decide to make a deeper or shallower grid later for a wider or narrower spot effect. Bend the scored cardboard so that the widest part is on the table and you've got the ends sticking up. If you put a book on either side, it will free your hands and keep the sides vertical. Then start gluing the straws to that widest portion of the cardboard. You want the straws to line up at the outer edge of the cardboard. Keep going until the space is filled and you can then fold the top down and seal the box by gluing the flap and wrapping it over. Then spray everything, inside and out, with flat black paint. For added sturdiness, wrap the sides of the grid with black gaffer tape. It should fit snugly enough as is, but if you like, you could make the box a little deeper and affix Velcro so it can attach to your flash (especially if you already have Velcro on the flash to hold barn doors).

The grid seems to focus the light, but it really doesn't. It simply blocks light going in directions we don't want. Depending on the area we want to light, we *may* have to buy a more powerful flash to compensate.

Supplies for a homemade grid.

Homemade grid.

Homemade grid on a flash.

We can use the grid for many purposes, but one common use is to light the background. Without a background light, the dark hat in this picture begins to disappear.

If the main light is a sunlit window, we could use our one other light as a background light. But in this case, the picture is too uniformly bright. The eye no longer goes directly to the subject. (Lighting is _also_ composition!)

Image made with a flash, but no grid. Depending on the setting of the flash, we can brighten the background substantially, but it's a flat background.

A grid solves the problem: We have enough background light to separate the subject from the background, but the background still has enough dark area to keep our attention on the subject.

Image made with a background flash with a grid. By adding the grid, we get a background with a brighter spot, which then falls off at the edges.

Making a snoot

A snoot does exactly the same job as a grid. It's much less effective than a grid, but we can make one in a few seconds with black paper and tape. (We should try to always have black paper handy. It is so often useful for needs we might not have anticipated.) Basically it is a small opening through which light will pass, thereby restricting the spread of light. In Chapter 3, we have an image made using a homemade snoot constructed from a cereal box. Isn't creativity great?

Learn what's available. Try a homemade version first. Use it a lot? Then consider professional versions.

Don't shoot madly. Study your images while shooting. Ask, "What would make this better?"

People see beautiful photos and wonder why they can't get the same result with their own camera. Often it's not the camera's fault. It's because we need a tool or two to amend the light. We each need to find those that work best for us. We don't need everything!

Lens filters

Most lens filters change the color of the scene, many of them dramatically so. In a black-and-white picture, a yellow, orange, or red filter could dramatically darken a too-bright sky; a green one could greatly increase detail in leaves. Today these "strong" filters have little use. We usually shoot color, and if we do want black-and-white, we can usually get the effect of colored filters by discarding some or all of any two of our red, green, or blue channels with photographic software after the picture has been shot.

Still, there are two lens filters we all need to consider:

Polarizing filter. Putting this as simply as possible, light vibrates in two directions—up and down and side to side. Depending on the angle of the light, one of those vibrations may convey all of the color while the other conveys nothing but glare (or, in Light— Science & Magic, "polarized direct reflection"). Do we want better color or more glare? The answer first seems to be color, but glare can be good, too. Think of seeing the ripples in the water (glare) or the fish

beneath the surface (no surface glare interference). Either can make a good picture. Depending on its rotation, a polarizing filter can block either of these reflections. Do we want the fish or the water? We don't know which you want, but we'd like for you to have the choice.

UV or haze filter. Ultraviolet is a color human eyes cannot see or can barely see. Our cameras see it though, and as it reflects from air molecules and dust over a great distance, it dulls the visible color and can turn our colorful autumn-leaved mountain into a dingy beige photograph. This filter blocks UV to increase color saturation. Whether we like this is another judgment call; if we have enough foreground color, the haze may emphasize the distance and size of the mountain in a way that we like. There is another advantage, even if we are not interested in landscapes: a UV filter at close distances has essentially no effect on the color, but this relatively cheap piece of glass can protect an expensive lens from damage.

Filter size. If we have more than one lens or expect to buy

Focal Press has other books that discuss how to adjust channels in more detail.

more, we'd like to have one filter to fit our largest lens and then buy step-down rings to make the same filter fit the other lenses. This is usually the most economical tactic, but still, it's not always affordable. Fil's largest lens polarizing filter cost more than many very good cameras do. It paid back handsomely however, because of the type of work he was doing at the time. Judge your own situation carefully. The "best" is not always the best for you.

Support: Stands, clamps, friends, and family

Somehow we have to hold all of this stuff together, and the ways to do that could make a whole book. Many of those ways can be pretty expensive, and if you are just beginning to learn this business you would much rather invest in lights, cameras, and lenses. Here are a few hints to make things easier:

Buy one good stand. We can get by with a lot of cheap equipment, but if our most expensive light blows over in the wind and hits a concrete sidewalk, that stand was not a bargain. We can support reflectors and gobos any way we please, but we want to protect our electronic equipment as well as possible.

Improvise. Photographers who don't travel much have made a very heavy, but very reliable light stand by sticking a wooden pole into a bucket of wet concrete and letting it harden. A few ropes and pulleys attached to the ceiling can support a big softbox as well as a ceiling track system costing thousands of dollars, although it will be slower to use. Buy the track system when you have enough photographic income to justify it.

Take a tour of your hardware store. There are a lot of expensive photographic clamps that do their job only slightly better than inexpensive spring clamps, C-clamps, and bar clamps. If you still need to buy an expensive photographic clamp to hold a boom, that doesn't necessarily mean you also have to buy an expensive photographic boom: sometimes a simple wooden dowel will work just as well. On some surfaces, duct tape works better than gaffer tape.

Gain weight. Less expensive stands become much more reliable if we attach extra weight to their base. There are clamp-on photographic weights to do just this, but tying on plastic bottles of water, bags of sand, or cinder blocks can also work. Just beware of the water bottle if you need to plug anything into an electrical outlet.

Get help. If your next-door neighbor can hold a light or a reflector for you, he may not reliably position it exactly as you want it, but at least he's not likely to drop it. Better still, join a local camera club. People with at least minimal photographic experience can take turns helping one another more effectively than the completely untrained.

Now, get to work!

A basic understanding of our tools is essential. This includes tools we don't have and don't intend to buy right away, but we do need to know when it *becomes* important to have them. Still, the tools themselves do us no good until we learn to use them. That's what the rest of this book is about.

Chapter 3: The Color of Light

IN OUR DAILY lives, we go through various types of light, probably without thinking about it. We wake up in the morning and turn on a lamp; go to our office, which is probably lit with fluorescent tubes; walk outside into the daylight for lunch; and then go back home at dusk. All of these environments bathe us in different colors of light, but we generally don't register the color shifts because our brains adapt so well. Walk from a sunlit bedroom into the closet where you've got the overhead light on. It's probably dimmer than the bright bedroom and the color you see is actually a different color, but our brains and eyes quickly compensate, and the stuff in the closet appears to be the right color and the room doesn't seem so dark. Our white shirt pretty much always looks white to us, wherever we are. In reality, it is a different white depending on the light source in which we find ourselves.

To get this lake image, the photographer had to wake up really early, had to be ready *before* the sun actually started to rise, and was prepared to work quickly because light at this time of day will rapidly change. We can see just a hint of pink in the sky. As the sun rises, the pink will spread and become warmer.

The color temperature of a light source determines what color the light is. We use the *Kelvin* temperature scale as a rating, so, for example, daylight (midday, when the sky is clear and cloudless) is generally between 5000° and 5500°K; whereas tungsten is generally 3200°K. Happily, we don't need to know a lot about the exact numbers for the most part. We just have to be aware of what our light source is and set the camera appropriately or use some color-correcting filters or gels. If absolute accuracy is needed, there are color meters to help us out, but most photographers can get by without one just fine.

What are "degrees Kelvin"?

Kelvin is a temperature scale, like Fahrenheit, Centigrade, or Celsius, but Kelvin also measures color. If we heat anything enough, it will glow. The more we heat it, the bluer its color. Of course, if we heat anything too much, it's likely to burn.

So we heat things in a vacuum. Without air, the thing we heat can't burn. That's why our old tungsten lightbulbs are made with as little air inside as possible. That allows us to heat the tungsten up to about 2800°K without immediate burnout.

The Kelvin scale is counterintuitive to most people. The colors that artists call "cool"—blues and greens—have a *higher* (hotter) Kelvin temperature, whereas the colors we call "warm"—red, yellow, orange—have a *lower* (cooler) Kelvin temperature.

For a simple explanation, ignore fluorescent lights. They are also measured in degrees Kelvin, but there is more going on there than Dr. Kelvin's old heat principle.

It's always better to make color adjustments in the camera rather than later with software!

Pretty much every digital camera today comes with settings for Sunny, Shade, Incandescent (Tungsten) modes, and some even accommodate various fluorescent light sources. (These terms may vary from brand to brand.) They also usually have an Auto Balance (Auto White Balance) setting where the camera automatically takes the amount of light and its color information and provides a natural white balance (not always reliably). Many cameras also allow us to create Custom White Balance (handy if we are using old softboxes or diffusion materials that have yellowed with age). Some cameras will also allow

us to actually enter the Kelvin number we want.

When we want the image to be as close to the way we perceive the scene, we'll want to be sure to set the camera to match our light source. If we don't, we'll get a photo that doesn't look like what we anticipate. We can mix and match if we want to have fun or create a mood, but if we're looking for "reality," then we have to learn to recognize our light sources.

We generally consider midday light on a clear day to be "normal" lighting. Most flashes are set to approximate this color of light. However, daylight actually changes based on the time of day, whether the subject is in shade and whether there is cloud cover. It can be very blue, red, or orange.

So now we know sunlight changes color during the day. When the sun strikes the subject directly, we see warmer light. When the day is bright but the sun doesn't strike directly, the color is cooler. Why? Think of a white building in an open

Early afternoon light. The sun is nearly directly overhead, hence the short shadows. This is the type of light we mean when we talk about daylight. A polarizer was used to make the sky bluer, which we'll explain at the end of the chapter.

The colors of sunrise and sunset can provide spectacular images. Just be prepared to work quickly because the light won't stay the same very long.

Early morning. This image, shot at around 7 a.m., was obviously taken in a different place from the one on the preceding page, but that's okay. The sun works the same everywhere. The warm tones are caused by refraction (bending) of the light entering the air at a shallow angle. (On a much smaller scale, we see the same effect from a diamond, a crystal chandelier, or a glass optical prism.)

The color of sunlight varies from day to day depending on cloud cover and the numbers and types of dust particles in the air. Air pollution also affects the color of the light. If we want the truly brilliant colors, we'll have better luck in areas with less polluted air.

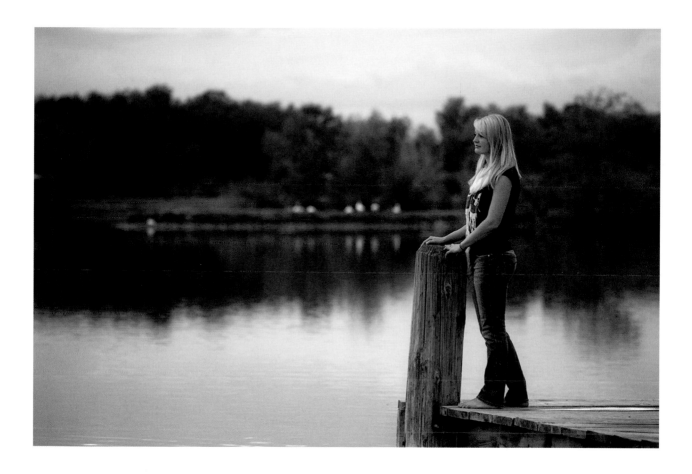

Early evening. The sun is lower in the sky and the colors are warm. The soft lighting comes from the diffusion the clouds cause. The light reflected off the water also helped fill the shadows on the model's face. No fill flash was needed.

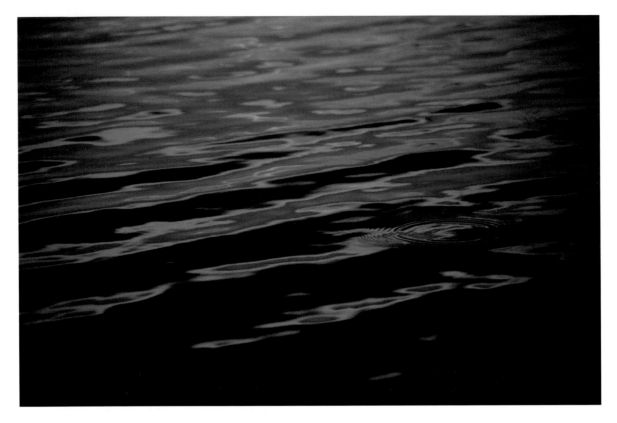

Sunset. There's no sky here, but we know it is a brilliant orange because it is reflected in the water. The photographer noticed fish surfacing and waited to get a shot with the resultant ripples. A ripple in the right place adds a point of focus. The shape, material, and texture of the subject can have as much effect on the lighting as the light itself.

space. The sunlit side will be both brighter *and* warmer (yellower) than the opposite side. Light still falls on the other side of the house, but it is light reflected from the open blue sky and the white wall on that side of the building will be dimmer and bluer. The open shade beneath a large tree will likely be greenish, instead of bluish, because the light is filtered through the green leaves.

This church is mostly lit with tungsten bulbs. With the camera set to tungsten, it is compensating for the yellow light, giving us a neutral-toned photo.

This same photo with the camera set to daylight white balance. The camera thinks that the light in the photo is daylight, but it is actually tungsten. The image is therefore golden. Which is right? That's your call.

Other light sources are available to us besides the sun. What are they and what color is their light? Tungsten lights produce yellow/orange light. These can be tungsten house lamps or quartz-halogen lights. (Quartz-halogen refers to the type of glass and the gas inside; the filament is still tungsten.) Candles sort of fit into this category, but their light is redder. If we leave our camera set to daylight but our light source is actually yellow, we get a yellow/orange image. If we want colors as we see them (that is, neutral-colored with our brain adjusting for the yellow), then we set the camera to tungsten; the camera will compensate for the yellow and we will get a neutral image with no yellow cast. (Under U.S. law, classic, energy-inefficient tungsten lights will become illegal to sell in 2014, but we predict they will be replaced by other lights of the same color.)

The only light source here is a household lamp with a big white shade. The telephone is just below it. With the camera set to tungsten, we get a pretty neutral image.

The only change we made here was to set the camera to its daylight setting. The image is very warm. Both approaches can lead to good pictures. We just have to decide what we want.

In the warm photos on pages 67 and 68, both cameras were set to daylight balance. Why is one warmer than the other? Household bulbs warm with age. As a result, the lighting is sometimes pretty, but it's seldom accurate. Photographers who need accurate tungsten (lower-budget video) always use the pricier quartz-halogen version with nearly constant color throughout the life of the lamp.

What happens when we go in the opposite direction, use daylight, but set the camera to tungsten? We get blue pictures. In the photo on the left on page 70, we set the camera to daylight and we get a realistic image of the black-and-white painted wooden cat. But it's a crazy cat. To emphasize that, we set the camera to its tungsten setting. The camera is expecting yellow light. It plans to neutralize that yellow into gray. However, our light isn't yellow, so the camera "corrects" the image to blue. Generally this is not what we want, but it's still worth playing with occasionally.

We have choices, too, when it comes to cloudy or overcast lighting. The images of the chess pieces were taken on a drab gray day. The chess board photo at left on page 71 was taken with the camera on the daylight setting. Because the light on this particular afternoon was bluer than the midday sun, we get a bluish image. If you want it warmer, try changing to Auto White Balance or Shade. All cameras in the Shade mode will warm the image made in open shade or overcast settings, some more than others and sometimes more than we'd like. This is a case where you need to experiment with your camera and see which setting you prefer. For the photo on the right (page 71), we set our camera to Shade and it warmed the image nicely. Is either one the right one? No. It's the photographer's artistic decision. The only time more people will almost always prefer the Shade

setting in this open shade lighting is when there are people in the photograph. Few people want their skin to be blue or green. (For practical purposes, we'll ignore the 50 BC British warriors, who painted themselves blue.)

Fluorescent lights come in four color spectra: daylight, warm white, cool white, and forget-about-the-color-just-make-light, but most of us can't tell which just by looking. However, if we do a test shot with no flash, we can

figure it out. Depending on the type of fluorescent tube, we're most likely to get an image with green light, although sometimes it will be magenta.

A few fluorescent lights have very accurate color: those used

in photographic light tables and viewing booths, plus a few workbenches used for assembling small parts. There are also photographic softboxes with fluorescent tubes approximating daylight color. All of these are too expensive for most general room illumination, however.

To make matters worse, many building maintenance people don't care what color fluorescent they use. Many work areas have a mix of tubes that add together to conform to *no* standard color.

Although few photographers like fluorescent lighting, we are still forced to deal with them. These lights are generally used as ceiling lighting for large spaces. Even though we can correct for the green or magenta hues (*if* the lights are all the same color), the people may still look awful because most light is coming from directly above and we get horrible shadows (remember the raccoon eyes). The only way to fix this is first to set our camera to the correct fluorescent white balance and then use a flash (in camera or off camera) to fill in those ugly shadows *with a gel* on the flash to make it match the color setting in the camera. Which gel we use will depend on the type of fluorescent lighting we're in. If we shoot with the camera on the correct fluorescent setting but don't gel the flash, the flash will make everyone look fairly orange. If we leave the camera on daylight and gel the flash, the color of the fluorescents will be evident in the shot. So if you are going to be shooting a lot in this type of light, carry a couple of gels specifically for the green and magenta fluorescent light types. They weigh almost nothing and they just need to be big enough to cover your flash head. (The Strobist gel collection includes a couple of gels of each color we are most likely to need, including fluorescent correction.)

Using gels for dramatic color

In the previous chapter, we mentioned colored gels only briefly, as we won't use them often in this book. However, for the photo below we wanted to warm our daylight-balanced light. We could have set the camera to its Shade setting to warm the photo, but that limits our control. We preferred to use a full CTO warming filter instead. CTO comes in a variety of strengths, so we could pick the one we wanted.

CTO

CTO means "convert to orange." A *full* CTO converts the color of daylight to the color of tungsten light—good to have on our flash if we are using a mix of our daylight-colored flash with old-time tungsten bulbs and we want the color of the lights to match. If we don't want the colors to quite match, we can get *half, quarter,* and *eighth* CTOs to put on our flash.

These theatrical gels have neither the color precision nor the optical quality of filters intended for use on lenses. This reduces cost. If we like existing tungsten light in a room, we may be able to tape a huge CTO sheet outside the window, making the outdoor sunlight approximate the color of the indoor light.

Yes, <u>of course</u> there are also gels to convert tungsten to daylight: CTB (convert to blue). We tend to use them less, though. Gels dim the light, especially if they are blue gels. If we have a few dim tungsten lights competing with the sun, we'd usually prefer to dim the sun with orange, rather than the other way around.

A CTO gel was used here with a homemade snoot made from a cereal box. This allowed the photographer to control the area of illumination so that there is just enough light on the face and a little spillover onto the hands. The CTO, with the camera set to daylight balance, replicates the illumination from the cigarette lighter but allows a much faster shutter speed or a much smaller aperture than the lighter alone.

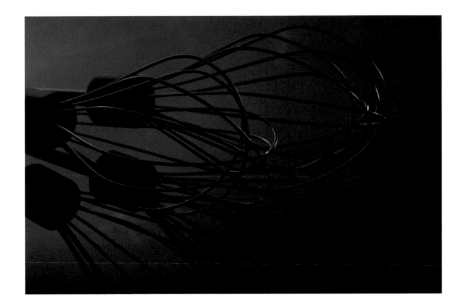

The photo above was done by placing whisks on a horizontal piece of black acrylic plastic with a vertical sheet of white foam board a couple of feet directly behind the setup. A flash was positioned on each side just outside the frame and aimed toward the foam board. The left flash was gelled red and angled about 45 degrees to the left. The right flash was gelled blue and angled to the right.

In the mountain lake photo on page 63 (a midday color of light image), a screw-on lens polarizer was used to blue up the sky. (Please don't tell other photographers about how you "blow up the sky" while you're going through airport security. Similarly, one of your co-authors, Robin, absolutely must not tell guards she's come to "shoot" several federal court judges!) The photographer rotated the polarizing filter to reduce atmospheric glare and increase the saturation in the sky color.

Still, even with the polarizing filter, sometimes the sky is too bright. In the snow photo on page 64, a *gradient* neutral density filter was used to gently darken the sky without affecting the foreground.

A *gradient neutral density filter* does exactly what the name implies: it darkens part of the image while exposing the rest of the image through clear high-quality optical glass. Bright areas get reduced exposure, whereas dark areas get increased exposure. Good idea? Absolutely, *if* the transition of the gradient happens to fit the scene. Getting the picture right in the camera

almost always surpasses the quality of fixing it later.

But what if the neutral gradient doesn't transition exactly where we want it? What if we want the darkness to go a little farther or a little less into the scene? Suppose we have to point the camera higher or lower to get that transition where we want it? Suppose we want a more abrupt or more gradual transition than the filter offers? The result can still be pretty good, but seldom

as good as what we might do with a controlled *alpha channel* in image editing software, where we can put the transition exactly where we want it and make that transition as gradual or as abrupt as we want.

But that's a topic for another book. In a basic lighting book, we will not overburden you with technical detail. Still, we absolutely must point you in the direction you need to be facing when you are ready to go there.

The color of light can be gratifying to play with and offers a fun way to start thinking about light. Still, often we can ignore it and take whatever color we get. As long as the daylight, the flash, or the tungsten is reasonably close to "normal," we may not even notice the color.

What we must *always* consider, though, is highlight and shadow. Let's explore that subject next.

Don't buy every filter/gel. Just know they're available. Buy as needed.

Chapter 4: Light and Shadow

THROUGHOUT THIS BOOK, we are going to work exclusively with the sun, the built-in flash, and the off-camera flash—all small lights. The sun, small? Yes. Although the sun is physically huge, it's also very far away, and thus it becomes a small light source.

Photographers call a shadow *hard* or *soft*, depending on how sharp its edge is. Nobody fails to notice the shadow in the photo to the left. Its edge is so sharply defined that it becomes an essential part of the picture. This is not simply a picture of a gourd: it is a picture of a gourd *and* its shadow. This hard shadow is an *essential* part of the composition.

Does the hard shadow make a better picture or a worse one? You decide. Whatever you decide, you may make the opposite decision for a different subject. You may even make the opposite decision for the same subject when you look at it tomorrow! The most important thing is to *make that decision*.

Good pictures don't just happen by magic. (Well, sometimes they do, but that "magic" usually comes from a photographer's well-thought decision, not luck.) So how do we make that decision? That's art, and we'll leave that to you. What we will do here is to talk about how to turn that decision into a photograph.

In this photo, we used a small off-camera flash behind and slightly to the right. We could have done *exactly* the same picture with sunlight, waiting for the right day and hour, if we were hobbyists instead of professional photographers with a contract deadline.

Hard-edged shadows from a small light source with little shadow detail.

It's also important to notice that the hardness of a shadow has nothing to do with how dark the shadow is. <u>Only</u> the sharpness of its edge matters. If we popped up an on-camera flash for fill, the shadow could be much lighter. Still, the sharp edge makes it hard.

Small lights make hard shadows. Furthermore, distant lights (unclouded sun) always behave as small lights, regardless of their physical size.

Because we are using the small light alone, we get the expected hard-edged shadows. Sometimes, that's exactly what we want, but certainly not always. Hard shadows are so noticeable that they become part of the picture subject; then they can compete with what we want our main subject to be.

Hard shadows can emphasize texture. That can be good if we want to show the worn engraved text carved into an ancient Egyptian stone; it's bad, though, if we photograph our middle-aged aunt who wants people to see her still youthfully smooth skin. We have to learn to make hard shadows, soft shadows, and anything in between to make the light suit the subject.

Soft-edged shadows from large light source with good shadow detail.

Want hard-edged shadows? Work without diffusion or move the flash farther away (making it a smaller light source). Shoot on a cloudless day at high noon. Want soft-edged shadows? Do the reverse. Shadows give shape to our subjects. We almost always want some shadow. How much? You decide.

Compare the gourd on page 81 with the one at the beginning of this chapter. The *only* change here is we've hung a large sheet of diffusion material between the flash and the subject. Because the diffusion material makes a bigger light, we get a soft-edged shadow. Within reasonable limits, the farther away the flash is from the diffusion material, the larger the light becomes, because it begins to light the whole sheet and, in effect, becomes a bigger light. We don't absolutely have to have a big sheet of diffusion material here. Other methods from Chapter 2 work just fine. Still, it's pretty difficult to put a big umbrella behind the sun.

Also, the closer the diffusion material is to the subject, the larger the light becomes. Remember that we said the huge sun becomes a small light because of its distance? We can apply the same principle in reverse: the closer we move the diffusion material to our subject, the softer the light becomes.

So when we want soft-edged shadows, we need a big light. Many flash units come with diffusers that snap onto the front of the flash; if we don't get one with the flash, we can usually buy one to fit whatever flash we have. These are simply translucent plastic. They look professional, but if professional appearance doesn't matter, we can just as well cut a piece of a translucent carryout container to fit the flash and tape it on. (Or just tape the whole thing over the flash, which will make it a little bit bigger.) The effect is the same. These indeed are helpful and certainly mobile, but they're still pretty small. The whole point of diffusion is to get a bigger light. To get a significantly bigger light, we have to use some of the tools in Chapter 2: diffusion material (including both softboxes and shoot-through umbrellas) and bounce (including walls, ceilings, white cards, and, once again, umbrellas). For now, we'll use diffusion sheets. This is the bulkiest and clumsiest way to do the job, but it is often the best in terms of both controlling the light and learning the light. It's also the cheapest.

Photographers have to use the play of light and shadow to create depth. It is how the viewer gets a sense of scale, shape, and texture. The keys to excellent photography are good composition, correct exposure, and good light. There are plenty of other books to give us tips on the first two. We're here to discuss light—its qualities, how it works, and how to amend it if what we've got isn't what we want or need. We want to be able to control the light. The artistic decisions should be ours. If we want hard- or soft-edged shadows, that's our call. But we want to know how to get whatever we want.

Let's look at some specific examples.

Texture

Subjects don't just cast shadows on backgrounds. There are also shadows within the subject itself that reveal shape and texture. Putting the right light in the right place makes this happen. The "right place" for that light is almost never on top of the camera.

This photo to the right shows the problem. The light on the camera certainly casts shadow, but the shadow is mostly under the subject. The camera cannot see much of the shadow, so there is not much texture.

Understanding this problem makes the solution easy: get the light off the camera. Sunlight works well *if* the sun happens to be where we want it when we want it. Household lamps also can work. Unlike the sun, we can move them to wherever we want. Household lights would work just fine with this piece of Belgian lace. Still, if the subject were moving—think of swarming ants or pouring flour—household lights might not be bright enough to stop the motion. Ideally, we would like to do this with a flash that is not attached to the camera, because that's the most controllable solution. We can

put the light exactly where we want it, and it's bright enough and fast enough to handle *most* movement.

The photo on the following page was made with a small flash at a low angle to the side of the same lace. The improvement is dramatic.

If we simply tell you to move your light to the side we're still not telling you enough.

The light needs to be small. Small lights make hard shadows, and that emphasizes texture. This

one is easy. It simply saves us the extra step of putting up diffusion material or getting out an umbrella.

*The light needs to be **much** farther from the subject.* At first, this is a little less obvious, but it's still easy to explain. As we move the light to the side, the part of the subject closer to the light will be much brighter than the more distant part of the subject. If the light is too close, it will be impossible to get good exposure through the whole picture.

Moving the light farther away also makes it a _smaller_ light! This, too, emphasizes texture.

We could solve the exposure problem by simply putting another light on the opposite side, and for some subjects, such as reproductions of paintings, that's a good idea. But we want to emphasize texture here, and using another light on the opposite side simply fills in the shadow we most need to do that.

By moving the light as far from the subject as possible, we get more even illumination of the flat surface. Think about that for a half-minute. If the subject is two

feet wide and we put our flash one foot to the right, the near edge of the subject gets pretty bright. A good exposure for the near edge means _huge_ under-exposure for the far edge. Now, think another half-minute about what happens when we move the light, say, 12 feet away. The near edge of the surface gets pretty close to the same exposure as the far edge. In fact, the whole thing is lit evenly enough that we probably need no subsequent digital manipulation to get it right.

So far, so good. We have a good picture of the lace. But we're not out of trouble yet. Let's try the same technique with a different subject.

The next picture is a black-covered book with an embossed title. Like the lace, there's no difference in color between the book title and the surface it's on. So we have to use texture to make the title visible. Sounds like we could use the same approach we used for the lace, right? Let's try that.

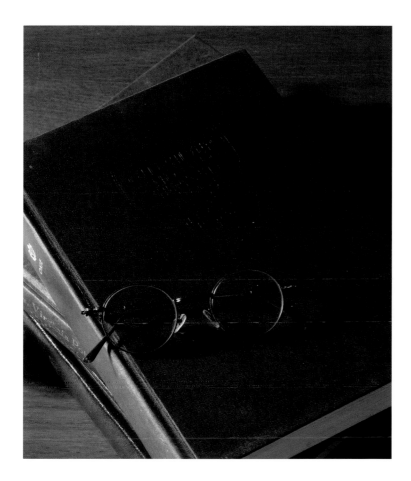

Grump! This is a terrible picture. But we've used *exactly* the same technique that worked so well with the lace. Why isn't it working now?

DIRECT VS. DIFFUSE REFLECTION

Diffuse reflection happens at any angle. Direct reflection is mirror-like. It happens at only one angle. Black subjects by definition emit little diffuse reflection. So, if we want to emphasize their detail, we have to look to direct reflection.

Why does the same light look so different on another subject?

Same light. Similar texture. One picture is good, the other bad. Why?

So far, we've been looking at *diffuse* reflection. Where the light comes from obviously makes a big difference in where the shadows fall, but the subject is about the same brightness, regardless of the direction of the light. With simple diffuse reflection, white things are always white and black things are always black. Plain and simple.

But that beautiful new black car our neighbor just bought is *not* black. It seems to gleam brighter in the sunlight than our own white car! How can this happen?

Not all reflection is diffuse. Some of it is *direct*, and a whole different set of rules apply here. Diffuse reflection can come from a light at any angle. *Direct reflection comes from only one angle, and if we are not at the angle to see it, it is invisible.*

Right now, pick up a white thing in the room where you are (maybe this page in this book, if you are reading it on paper). Turn it and look at it at different angles. It stays white, no matter what angle. If the angle doesn't affect brightness, we're looking at diffuse reflection.

Next, pick up a black thing (maybe your telephone). Look at it while you turn it to different angles. Whatever light you have in your room, the highlights will move as you turn this thing. We are looking at direct reflection here. Our telephone changes brightness as we turn it.

So we have two types of reflections, and they work in totally different ways. With black subjects, learn to capitalize on direct reflection, not diffuse.

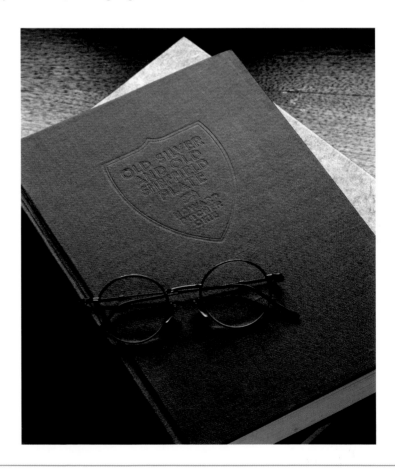

Noise

Noise is the worst problem any digital photographer has to deal with, so let's get to it right now, early in the book. Noise is a result of how our cameras handle the light. It is exaggerated whenever our camera needs to amplify low light levels to get an adequate exposure. But what is noise?

Noise is any random electronic impulse that has nothing to do with the picture. It can come from cosmic rays, a passing car or motorcycle, or the camera itself. Wherever it comes from, it degrades our pictures, and we want to get rid of it. It is especially noticeable in areas of smooth or solid color.

More megapixels. The least expensive digital cameras already resolve everything the lens can see. Why would anyone ever pay the price for a camera that produces more pixels than the lens can resolve or the eye can ever see? But that's just the whole point of the argument: get the pixels small enough and the eye can't see the noise. The bad part is that this solution leads to hugely increased file sizes, slower computer processing, and a waste of all of our resources.

Nighttime photo in mixed light. Camera was set to Auto White Balance. Because of the high ISO, there was a lot of noise. In this case, Lightroom was used to reduce the noise. So how do we reduce noise? Three ways, and you're not going to like any of them: buy a more expensive camera, increase exposure, or get software like Adobe's Lightroom. Let's talk about them.

We had to shoot the cover shot of the Sikh twice. We started out with a cheaper camera. This section shows that the noise was unacceptable.

This is a similar portion of the headshot, but this one was done with a camera that has more megapixels. No noise problem!

Increase exposure. This totally eliminates the noise problem, and it works with a cheap camera. Increasing exposure brings the whole picture up to the level of an orchestra playing a great symphony at its loudest moment. No one notices a cough in the audience at that point. The problem with increased exposure is that it destroys highlight detail. Light grays all become white. Different light colors all become the same color. Still, one of the main reasons we learn lighting is to keep the highlights and shadows within a small enough dynamic range that we keep detail in both the highlights and the shadows.

Software. There are various software packages that come with noise reduction/correction capability. Their success varies—both because of their capabilities and because of the amount of noise in the image.

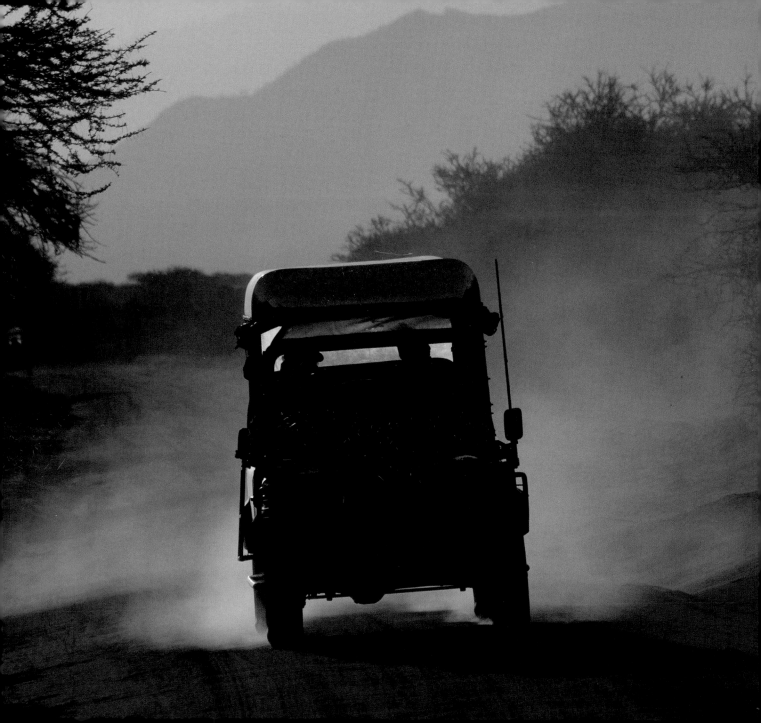

Chapter 5: Sunlight

SUNLIGHT IS GREAT, and not just because it is free. It can be our main light, a fill light, or a hair light. Depending on the time of day and the weather, it can be a big or small light source. Sometimes it's perfect without our use of flash at all. The most serious downside is that the weather is unpredictable. The other disadvantage is that we can't move the sun to whatever spot we want: the sun dictates the schedule.

We can _always_ know in advance, anywhere in the world, where the sun will be in the sky at any time of day. The U.S. Naval Observatory provides that information for free on its website. Because the site is in continuous development, we can't give a specific web address, but seek and you will find. For cloud cover, though, we have to guess from local weather forecasts.

Found light

Sometimes we simply get lucky and find ourselves with something great to photograph when the light is perfect as is. These times are gifts. (And "perfect" doesn't always mean sunny with a bit of cloud cover!)

The image below is an example of not being put off by "bad" weather. The distance from the camera to the ship meant that even the best flash in the world wouldn't have the power to light the ship. In this case, more light would have ruined the image. Here it was a matter of staying

open to possibilities, sitting and waiting, and getting the exposure right.

The courtyard photo on the next page also uses existing light, but what a different quality of light it is! And that's not just because it wasn't foggy. The image almost

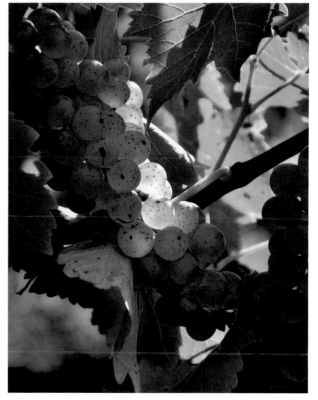

looks like a painting. We were too far away and the subject area was too big for most photographers to have any realistic chance of amending the light. (Yes, there are photographers who have enough equipment to handle a scene of this size, but not many.) It was taken shortly after noon, so you'd expect hard shadows. But

Dappled light filtering through the grapes. Nothing more needed than to get the exposure right and, of course, to learn to stop, look around, and see the possibilities.

because the light was bounced off the lighter colored walls, everything was gently lit.

So no one kind of light makes for the perfect photo—gray days, noontime, a mix can all work. Sometimes the light can be right but the subject is just in the wrong place. The butterfly in the photo on the left on page 95 landed on the pavement at our feet. Although the light is just fine for the butterfly itself, the noon sun casts a long shadow. The shadow is hard, for two reasons: one, unclouded sunlight is always hard, and, two, the butterfly is so close to the "background" (the pavement). *Regardless of the size of the light, a background shadow is harder if the subject is closer to the background.*

Butterflies don't stay put very long—certainly not long enough for us to put a reflector in place (which would probably scare it away anyway). So we waited for it to move to a bunch of flowers and hoped it would alight on a tallish flower. Okay, the same butterfly didn't cooperate. But a different one did. In the second butterfly image on the next page the height of the flower meant that the shadow wasn't cast on anything close by; therefore, we

get good detail in the butterfly but without the distraction of the shadow. If we had really needed the same butterfly, we would have had to stick around longer. Patience, if we can afford the time, is always helpful. Ansel Adams went back to some of the same sites for *years* before he got some of his classic images.

Open shade can also work well, although we need to be aware of the color of the light. In the shade of a building, the color will be affected by the wall's color. Under a tree, the light will likely be green. In the photo on page 96, the boy was playing in the open shade of a large tree. Since the photographer chose to

If we need to photograph a cold-blooded animal and we can catch one, just a few minutes in the refrigerator will slow it down. Then we can put it where we want and it will sit long enough for our picture. This should only be done (very carefully!) with reptiles or amphibians that we know can survive cold weather well. Cruel? Probably no more than sending our children to walk to school on a winter day.

convert the image to black and white, the green light no longer mattered. However, had he not done that, he probably would have had to either put his camera in Shade mode or do some color correction in postproduction.

Lighting children doesn't differ from lighting adults. They present a different challenge in terms of language skills, hyperactivity, shyness, or crankiness (probably because the sitting was scheduled at nap time). One of the hardest issues to face is the cheesy, fake smile all kids seem to develop at some point. You can deal with this challenge by developing your people skills, but the solution has nothing to do with changing your lighting approach to these small subjects.

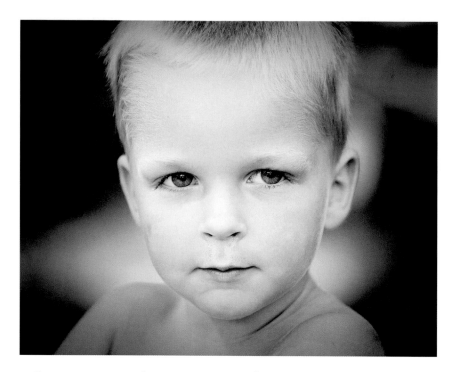

Aperture refers to the lens opening. A wide-open lens (say f/2) lets in a lot of light. However, there is a trade-off. With the lens wide open, we get shallow depth of field, the area of acceptable sharpness. If we want everything to be sharp, we have to go to a smaller f-stop (say f/32). This means increasing the power on our light sources, if possible, or changing to a higher ISO.

The image above was taken in open shade under a tree. Opening up to a large aperture allowed the background to go out of focus and draws us to the subject's face. Always look for a variety of expressions. We have no smile, but we do have a compelling portrait.

Amending or mixing light

So what do we do if the light isn't just the way we want it? In the photo of the boy on the previous page, no help was needed to get a nice shot, even though it was a shaded area. But how can we fix the lighting when we are outside and the light isn't what we want?

In the upper photo here the flower was in the shade. We sense the delicacy of the flower, but it's all rather drab. We tried the in-camera flash (bottom photo), but because the light came from directly in front of the flower (and therefore fills those informative shadows), we lose the texture of the petals. In the subsequent photo on the next page, we held a reflector angled so it reflected back the sunlight onto the flower. (Now we either need a friend to hold the reflector or, if we're by ourselves, we need to mount the camera on a tripod.) We retain the delicacy but add a little brightness to the flower.

We can apply this same technique when shooting photographs of people in open shade. We could certainly use a reflector (bigger than the one we would use for shooting a small flower), use the

built-in flash for fill (maybe with some neutral density material), or just switch to the Shade mode. With a little experimentation, all photographers will find what works best for them.

Sometimes the light is almost just right, but we need a little kiss of additional light. The photo on page 99 is actually a self-portrait of the photographer facing away from the camera. The sky was a bit gray, so the photographer added a screw-on polarizer, which held onto the cloud detail. The exposure was set so that the sky and clouds looked right. The photographer could have stopped there, but the lower body was blending into the background shadows. Adding one flash was the way to provide some definition. The light on the lower left arm in this photograph did not

Try different camera angles and heights. The first placement may not be the right one.

come from the sun but rather from a flash on a low light stand and angled so it mimicked the sun's lighting—just enough to provide separation from the background.

To get the focus for the photo, the photographer put the tripod where he eventually planned to stand. He noted where the tripod was so he could eventually stand in that spot. He then stood back and framed the photo in the camera. He focused on the tripod. He then brought the tripod back to where the camera was, put the camera on the tripod, and reframed the shot.

He placed the off-camera flash where he thought it should go. He used the camera's self-timer to take the picture and had a wireless radio control attached to the camera to fire the flash. Wireless radio controls are neat gizmos that allow us to trigger a flash without the flash being connected to the camera. They're nice because no cables are needed. If they're good, they also don't need a line of sight to the flash and the sunlight won't confuse them. (Think about your home radio. It gets its signal right through the walls that light can't

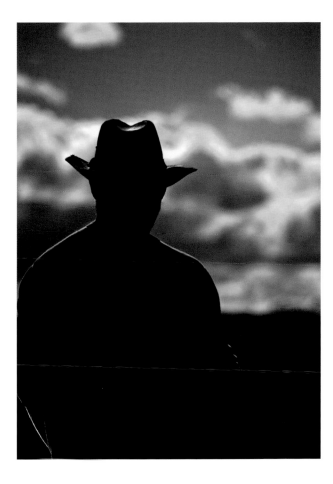

this case, because getting the right expression or movement wasn't critical, the self-timer was just fine.

So now, we can both take the photograph and watch the sunset—all at the same time.

Taken at a different time of day, the sun would act more like a hair light. In this photo, a silhouette is all that is needed. No fill flash is necessary. More frequently, we do want some more information. Using the same approach but earlier in the day, we'd be inclined to use this backlighting more as a hair light. With the subjects facing the camera, we're more likely to want to get some additional light into the faces so we can actually see who they are.

Using the in-camera flash as a fill light outside may be the most important value of this little light. It works very well. However, with

penetrate.) But what if we don't have a wireless radio control to fire the flash? After all, these can be pretty expensive. We could use a synch cord attached to both the flash and the camera. Don't have a synch cord? Go back and use that little mirror to direct the

built-in flash to the off-camera flash like we did at the beginning of the book.

If we wanted more control over when the picture would be taken, we could have used a long cable release instead of the self-timer. In

Use a lens hood, especially when outdoors. It helps to avoid flare.

a little more work, we can make the image more interesting. Again, by using a light directly in front of the subject, we get flat lighting. Works fine in a pinch, but for a more refined image, we'd prefer to add an off-camera flash and possibly a reflector.

In the top photo, we have an example of the sun creating backlighting. It just doesn't happen to be outdoors. The light came from two windows, both behind and to the left of the cat. These windows were on two sides of the corner of the room. With the help of the white bedspread we got some fill light going on, but the face was still a little darker than we'd like. This particular cat wasn't crazy about the flash, so for the bottom photo we opted for a simple white fill card merely leaned against the dresser. Note the increased light in the face and the additional brightness in the eyes. The cat was not stressed and we were happy.

The photo on the following page is an example of shooting a beautiful subject in a beautiful place. The only problem was that the light actually was bit flat. So how might one remedy this problem?

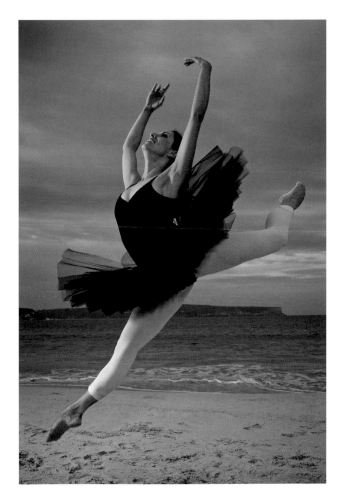

flash to warm the light so it would look like warm afternoon sunlight. The sand acted as a reflector to fill the shadows that occurred and no additional lighting was needed.

For those who are particularly interested in close-up photography of flowers, here's an approach that works well. We'll need a lens that can handle close-up focusing, or we can add *extension rings* (assuming the camera accepts different lenses). It means carrying a bit of lightweight equipment, but with it you can create beautiful soft light. To handle harsh midday sun or deep shadows in a forested area, this photographer uses a combination of diffusion and flash. He bends a 6-foot round diffuser into a "U" shape to form a little tent (held in place usually with stick placed into the ground at an angle to hold the diffuser in place—no holes in the diffuser, please!). Sometimes this is the only adjustment you'll need. In the photo of the mushrooms on the next page, however, the photographer needed an accent light. He used an off-camera flash as seen in the bottom photo, which shows the setup. An alternate approach is to lean the diffuser against a tree and put the flash behind it, in effect creating a softbox.

The sky was gray. In this case, the photographer put a polarizer on his camera to bring out what blue there was in the sky. (Note that polarizers *may* not work on gray days—try it and see what happens.) As might be expected on a gray day, the light wasn't directional. To add the feeling of more sunlight, the photographer put an off-camera flash in a softbox at camera left and positioned it fairly high, angled downward. A full CTO gel was placed over the

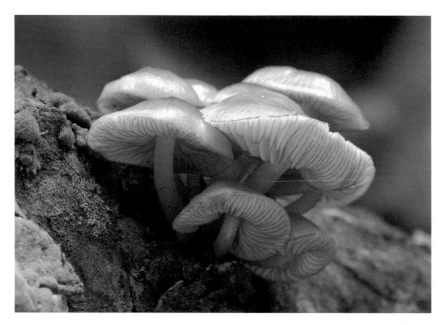

Mushrooms growing on the side of a log in dense forest with little light. Using a diffuser with a flash gave the added light needed to make the color of these unusual little mushrooms pop.

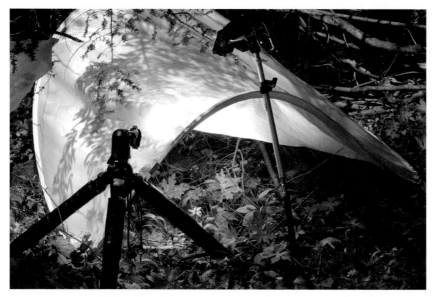

Setup for outdoor photography using flash and a diffuser.

Distance and haze

Haze happens for two principal reasons: dirty air and ultraviolet light. Whatever the cause, we see more of it in distant subjects simply because there is more air between us and the subject.

Haze degrades the image, but that's not always a bad thing.

Look back at the first picture in this chapter. The haze both enhances the feeling of distance and emphasizes the foreground subject.

Still, if the background were our primary subject, we probably wouldn't be too happy with the photo. In that case, either or both of two remedies might work:

Use a UV filter. If ultraviolet is the cause of the haze, a UV filter can make a big improvement.

Shoot early in the day. In many locations, there is less smoke and dust in the air earlier in the day before vehicles get on the road. In other locations, morning dew dampens the dust and keeps much of it out of the air.

Architecture

Usually we want the sun coming from the front of the building and low enough in the sky to put light into overhangs. This means almost never shooting at noon when the sun is directly overhead. We'd prefer to shoot in the morning when the air is likely to be cleaner, but we have to shoot later in the afternoon, depending on where the building faces.

The "front" of the building is sometimes a judgment call. What seems to be at least three buildings here is to some extent a single building with much more than a century of expansion; what appears to be the front entrance is actually a rarely used doorway. Still, it *looks* like a front entrance, so we used it as such when we picked the time for the right sun and camera position.

The photo above was taken in early evening and converted to black and white. This photographer used a 30-second exposure to allow for some movement in the clouds. The star effect is a natural result of the light reflecting from the lens aperture blades. We don't have a lot of control over when this happens or whether it's a "good" or "bad" effect. Still, if we decide it's bad, we can usually remedy it.

When the effect is bad, it usually appears as flare coming from a too-bright light just outside of the camera view. We can block that with a black card (gobo) or even with a hand or hat. When we want the effect, but don't see it, we can add a *cross-screen* or *star* filter to the lens. Or if we do not want a very sharp picture, sometimes a piece of metal (not plastic) window screen over the lens can get the same star effect, plus a bit of diffusion.

But enough of this outdoor photography! As we write it's starting to get cold outside, so let's move on to something we can more often do indoors: portraiture.

Chapter 6: So, Where Do We Put This Light for Portraits?

THERE ARE A lot of things happening in this picture of Civil War reenactors, but none of those things is very difficult or complicated. Two lights and a couple of gels. We'll start, however, by talking about a few of the simplest parts, and then we'll go on from there.

Learning to control the light is what this book is all about, and that control works with glass, metal, flowers, mountains, oceans, donkeys, and most other things. Still, we'll stick with the studio portrait for now. That's because most of us can find a subject willing to cooperate. (The sunlight over the mountain may not cooperate and your pet donkey certainly will not.) Also, the portrait is a fairly simple subject that we can deal with in a fairly small space with our own light.

We're going to assume you have one big light, maybe a window, maybe an external flash, plus a fill light: the little light built into your camera. We'll also

hope you sometimes have a third light. The third light doesn't need to be an expensive electronic device: a large silver or white reflector indoors, the sun coming from just the right direction to do something good along with your external flash.

Portraiture, while challenging, can be wonderfully rewarding. There are various lighting styles to choose from. We need to learn them all, but not all at once. Learn one, master it, and move on to the next. The style we use depends on whom we are shooting for: ourselves, an art director, or the subject? The approach that is right for one may not be right for another. Art directors may want the subject to look angry, silly, or meaner than all get-out. People looking for a portrait to give to their mother usually want to look pretty or handsome and sweet. A professional athlete may want to look as tough and nasty as possible.

Regardless of which lighting style we are working with, we'll generally need to adapt our setup a bit for each subject, based on bone structure and skin tone.

We can light a portrait any way we want. Still, there are a few classic styles to start with, such as split, Rembrandt, butterfly, beauty, and rim/kicker. All are good, and it's a matter of taste as to which we use and when, as well as what the end purpose of the portrait is.

Use a tripod. We can make quick small adjustments to lighting or pose and not take time to reframe when we get back to the camera.

Split lighting

Split or hatchet lighting involves lighting from the side of the subject only. In the photo below, we did the same lighting setup as we did for the Sikh in profile in Chapter 1, using just our little silver reflector to bounce the light from our in-camera flash to our large white board. The difference here is that the subject is facing the camera directly. We wanted as little light to hit the shadow side as possible. If we are shooting in a really large room or a room with black walls, it will be easier to keep the shadow side dark. In this case, we hung black velvet very close to the subject on the opposite side of the board to limit the light being bounced back from elsewhere in the room. If shooting in a smaller room with light walls, we'll get automatic fill from those walls and we might have to do

postproduction work to deepen the shadow side. This type of light brings out the texture of the sculpture, which is fine for the sculpture. It will do this for skin as well, and this should be taken into account when using this lighting style.

In this head shot, we placed the off-camera flash into a softbox so we could get a rectangular catchlight in the eye (so it looks like window light) and placed it a tiny bit in front of the subject so we got just a bit of light onto the shadow side of the face and can see a bit of the second eye.

GRAYSCALE (BLACK-AND-WHITE) IMAGES

There is no need to light differently for images intended to be grayscale (black and white) or color. We do need to be concerned that in grayscale some grays may blend together. Photographers once fixed this problem with colored filters to turn different colors into different grays. Usually there is no need for that any more: shoot RGB color. If we want the effect of a red or green filter, we just delete the other color channels. Same effect.

Short lighting

Short lighting is where the shadow side of the face is closest to the camera. The play of light and shadow brings out the shape of a face. Many photographers refer to this as *Rembrandt* lighting, but in reality Rembrandt lighting is a specific form of short lighting defined by the placement of the shadow so that there is a triangle of light on the shadowed cheek. It is named after the master painter who used this style of lighting frequently in his works.

In the photo below, we used our off-camera flash as our main light. It was placed to the camera's right side and slightly in front of our subject with a large sheet of diffusion material hung from a seamless stand. We used the in-camera flash as our fill light. In this case, we folded up our sheet of neutral density material several times because we wanted just a little bit of fill light. If we wanted less contrast between the two lights, we could have just used less of our neutral density material. There isn't a right or wrong here, just a matter of taste. Always experiment— different faces handle the same lighting setup differently. What we like for one, we may not like for another.

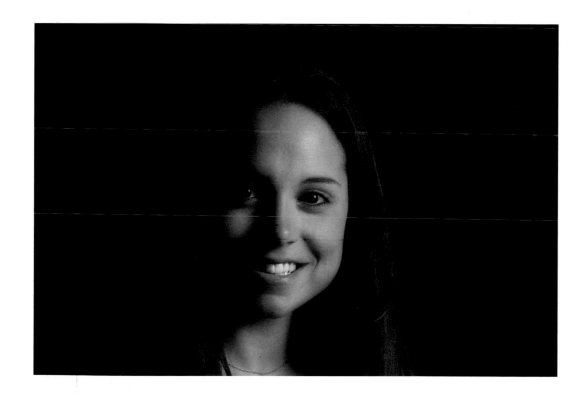

Broad lighting

Broad lighting is pretty much the opposite of short lighting. It is when the light side of the face is closest to the camera. This tends to leave the face fairly flat with little bone definition. It is good for thin, angular faces. Generally it is avoided for round faces, as it makes the face look even broader. However, this approach is worth knowing and practicing because there are always going to be times when we either just need a different look or a face isn't working well with short lighting.

Sometimes these names can be confusing, but it helps to think that broad lighting uses a "broad" swath of light to cross the face. Short lighting, on the other hand, makes use of shadow and has just a little or "short" amount of light hitting the face.

In the photo below, our main light, the off-camera flash, was placed on the opposite side, while the sitter is still in the same basic pose. As a result, the part of the face closest to the camera is now the more brightly lit. Our sitter has great cheekbones, and we still get a hint of them even with this lighting, but the face appears broader with this type of lighting.

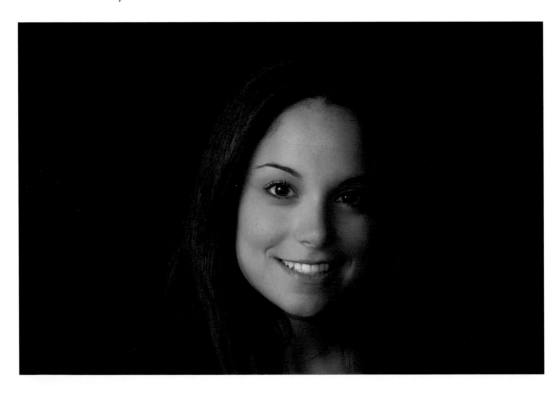

Hair light

In the photo below, a hair light is used to bring out the texture and sheen of the sitter's hair and to separate the subject from the background. Our subject has dark hair and we've got black velvet for a background. In all of the preceding images, some part of the hair blends into the background. Had she been blond, this wouldn't have happened.

Regardless of hair color, a hair light is a nice addition.

For the photo on the following page, we used the same lighting setup as we had for the Rembrandt lighting technique. We used less neutral density material on the in-camera flash, so we had gentler lighting. We used an additional off-camera flash for the hair light. Even if we don't have two off-camera flashes, this

photo could be done if we used the sun coming through a large window as our main light. If the sunlight is particularly bright, we'd like to use a sheer curtain to soften the light. If we don't have the big window, then it's time to borrow a flash from a friend!

In our photo here, we used this flash with a silver umbrella, but you could also opt for a snoot or a grid. Most photographers

like to place it so that it lights the shadow side of the hair (on the side opposite where the main light is placed). The hair light in this case is placed behind and to the sitter's right (camera left) high enough and at an angle to broadly light the hair.

Between the added fill light and the hair light, we now retain more detail in the hair, and where the hair light falls, we get a nice sheen to the hair. It also adds depth to the image.

Don't automatically print the full image as shot. Cropping can often strengthen an image.

A boom light stand makes it easier to place the hair light, but it is not essential. Don't use a hair light with a white background. The shiny hair disappears into the background. And don't use a hair light on bald subjects.

Background light

Different backgrounds have an impact on the final style of the portrait. While most photographers stock various shades of seamless paper, they may only have one or two painted canvas backgrounds as they are considerably more expensive. Regardless of the background, by using a backlight, we can effectively control how dark or light a background is.

Up to this point, we've used either black seamless or black velvet. For the photo to the left, we changed to a painted canvas background. A great many styles are available, or you can paint your own. This one had fairly dark tones. We wanted a more midtone background. There are two ways to brighten a background. The first is to move the background closer to the subject. Immediately, the lights we are using for the subject will also brighten the background because it is closer. If subject

and background are too close, we can get shadows on the background cast by the sitter. Although this can work on occasion, we generally don't want this effect. We can sometimes eliminate these distracting shadows by raising our main light so that the shadows will be cast at an angle where they hopefully will fall behind the sitter unseen by the camera.

An easier way is to use a background light. Place a flash on a short light stand (or on some boxes) behind the sitter and point it at the background. Use a silver reflector and barn doors for more control. The reflector will make our little light bigger, and the barn doors will restrict the light so it falls off at the edges of our image. If we place them correctly, we will see the background lighter behind the sitter and then darker at the edges.

In the image on the previous page, we've got four lights at work: main (key), fill, hair, and

background (with four barn doors to restrict the spread of the light). This technique is doable with three lights and the sun, but it is still more than the simple lighting (two lights) we are mostly concerned with in this book. Something for future consideration.

FEMININE VERSUS MASCULINE

In the photos on pages 111, 112, and 113, our model is in the male pose. The body is turned toward the main light. The head is turned back to the camera and is in line with the spine. In the photo on page 114, our model is in the female pose. The body is turned away from the main light. The head is turned back toward the main light and tilted a little bit, creating sort of an S-shape. Women can do both male and female poses. Men should stick with the male pose. Men tend to look somewhat silly when their heads are tilted as in the female pose.

Rim lighting/kicker

Rim lighting is used to separate the subject from the background. Unlike a back (or background) light, where the light is pointed at the background, in rim lighting the light is pointed at the subject. It is placed so just a bit of light outlines the subject.

The portrait below uses two off-camera flashes. The first was placed in a softbox at camera left and about 45 degrees above the subject. Because of its placement to the side of the subject, we get split lighting as we described earlier, but because the light was bigger and there were light walls, the contrast is less than as shown earlier. The second flash was placed slightly behind the sitter and acts as a rim light; it provides the separation needed for the shoulder and hair from the background.

Kicker lighting is what we used in the photo at the beginning of the chapter with the Civil War reenactors. Basically, a kicker is a light that comes from the side, often to give a bit of extra brightness or definition. This example presents a stronger version of kicker lighting than is commonly used. We wanted a sense of light coming from a bonfire and thus used a large softbox to the camera-left side of our subjects (their right) with a full CTO gel in front of it. We had a second light in a small softbox just to the right of the camera with a dark blue gel over it, quite high up and angled a bit downward toward the subjects. The photo on the next page shows the image as shot. We had planned to use our smoke machine for this image, but it unexpectedly would not work. Without time to have it repaired, we let our models go home after getting the basic shot; then we photographed cigarette smoke separately and put it into the image with postproduction work in Photoshop. This situation offers a good lesson—one way or the other, the photographer has to get the job done! Two lights, two gels, and a little software magic was all that we needed. Although we used two off-camera flashes in softboxes, it could have been done with a single off-camera flash with diffusion material and a CTO gel at the side and then blue gel over the built-in flash. The blue light would not be positioned as high

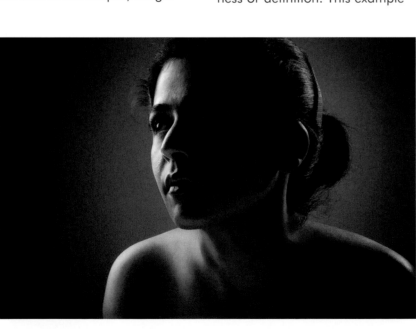

as we liked, but the setup would have worked.

Postproduction work is an integral part of a photographer's work these days. Compare the photo below with the image at the beginning of this chapter, which combines three photographs of smoke, adds some selective softening, and incorporates a small amount of vignetting. The additional work in postproduction makes a world of difference. In Chapter 10, we'll discuss postproduction more.

Butterfly/Beauty lighting

Butterfly lighting is where there is one light placed directly in front of and a bit above the subject at an angle to create a shadow under the nose that is shaped like a butterfly. Depending on the facial structure, we often want a bit of fill, which could be the built-in flash, but a bit of foam board offers more choices as to what gets filled. In the photo at right, we used a flash with an umbrella as the sole light source. (We added the dark vignette in postproduction.)

Beauty lighting uses a larger light and a reflector or second light is placed below. The goal in beauty lighting is to make most of the shadows disappear.

Beauty lighting is frequently used in, guess what, ads showing flawless skin for beauty products. The light is such that shadows are pretty much filled with light, leaving almost no wrinkles! On the following page, for the image on the right, we used an off-camera flash in a softbox placed above the camera facing the sitter. A silver

reflector was placed just out of the camera's view, angled to reflect the flash above. We could have used a second flash below, but for most of this book, we're assuming you don't have two off-camera

flashes. If we had used a second flash, we would have used it with either a softbox or an umbrella. You can see the difference the fill card makes by comparing it with the image on the left.

Without fill card

With fill card

Low key versus high key lighting

Both low key and high key lighting create lovely portraits. One isn't better than the other. Low key lighting tends to have a classy feel to it; high key lighting tends to be more contemporary.

The trick with either is to shoot a portrait so that the face is the part the viewer looks at first. How do we achieve this? When the clothing and the background are similar, the face becomes the different part and therefore the viewer's eye will go to the face, which is exactly what we want in a portrait. The background and the clothing don't have to match exactly, but they should be approximately the same brightness.

If the subject is wearing dark clothing (preferably a solid color), then opt for a dark background and low key lighting. The background can be a solid color (seamless paper), a painted canvas background (with a bit of light on it), or even a white wall (assuming it is a very long way away from the subject, so that it receives little if any light and therefore will photograph dark gray or black). Low key portraits also tend to have less or even no fill light to take advantage of the play of light and shadow.

If the subject is wearing white or pastel-colored clothing (again preferably a solid color), then opt for a white background and high key lighting. This can be white seamless or a white wall, or even black seamless with lots of light on it. High key portraits tend to use flatter lighting than low key portraits have, and therefore they have less shadowing.

The use of similar density clothing and background and the amount of shadowing determine whether a photograph is deemed to be low or high key. These are not hard-and-fast rules but rather guidelines. It's certainly possible to get lovely portraits and not follow these suggestions, but these guidelines are a good place to start.

VARY THE CAMERA AND LIGHTS

Be sure to try different camera heights for portraiture. The same pose from a slightly higher or lower camera angle can have a dramatically different effect. Of course, as you raise or lower the camera, you may have to do the same with the face's angle. Watch what happens to the shadows. You may also have to raise or lower your main light! Sometimes out of one pose we can get multiple images that feel completely different.

Stripes and patterns distract from the subject's face. Have the sitter wear solid colors!

style does accentuate wrinkles, sometimes they are part of the subject's charm. How much you accentuate them is determined by placement of the main light and how much fill you use. Because the clothing and background are dark, the viewer's eye is drawn to the light area, namely, the face. By using very little fill light, we created a compelling portrait of someone who has lived a rich life. Adding more fill light would have filled in those shadows that in this case we wanted to keep.

Generally we want to place the main light so it skims across the face and ends at the near cheekbone. The placement will vary from person to person based on the subject's bone structure. We also want it at a height so we get a good catchlight in the eyes. If the light is too high and there is no catchlight, the person tends to look lifeless—not generally a goal in portraiture.

Low key portraits can be quite dramatic. To a large extent, it depends on how much fill we use. Shadows define the face shape. In the photo above, we have an absolutely lovely older woman, again using the off-camera flash behind some diffusion material as our main light with our in-camera flash as fill with folded neutral density material, because we wanted very little fill at all. There is *no* white board or reflector. Although this

Many photographers shy away from low key portraits of older subjects fearing that the subject won't like seeing the wrinkles. Don't be afraid of this technique. You can create wonderful, charming images this way.

We blocked the popup flash so none of its light strikes the subject. It was used solely to trigger the off-camera flash. We started with the off-camera flash placed close to the diffusion material and almost directly to the side of the sitter. It's essentially split lighting. Our eyes bounce back and forth between the light and dark areas. The wrinkles are pronounced.

High key portraits tend to use more even lighting than low key. The effect is meant to be light and airy. They use a white or light-colored background (often seamless paper or muslin or a white wall or sheet). The sitter wears white or pastel-colored clothing. Again, this will draw the viewer to the different part of the image, namely, the face.

In the following three photos, we show how to transition from hard lighting to the softer lighting we want for high key images.

We put the off-camera flash farther away from the diffusion material and moved it so that it was at more of a 45-degree angle from the sitter. This allowed the light to wrap around more of the face. We also used the built-in flash with some neutral density material in front of it. The wrinkles immediately are less pronounced, we get better detail on the shadow side of the face, and we get a catchlight in both eyes instead of just one.

Here we simply took away the neutral density material in front of the popup, thus brightening the fill light.

Clothing with long sleeves also helps direct the eye to the face.

For high key images, we almost always use a background light in order to keep that background truly white. Without the background light, we would have to keep the background really close to the subject in order to keep the background truly white, but this increases the likelihood of shadows falling on the background. By raising our lights, we can often make the shadow disappear behind the subject, but this entails having all of our lights be off the camera. Because in this series of photos we are working with the built-in flash, which cannot be repositioned, we either have to use a background light or settle for a gray background.

When shooting images that encompass more than just head and shoulders, we will often need more than one background light if we want more of the background to stay evenly lit. Frequently, we can't put a light directly behind the subject, but we would rather position one or two lights on each side of the background and meter the lights so we get even illumination across the background. A general rule of thumb is to have one to one-and-a-half stops more light on the background than on the subject. Depending on the placement of these lights, sometimes we will need to use gobos or barn doors to prevent the illumination from these background lights from also lighting our subject, which we don't want.

In the photo below, we indeed used four lights on the background (two on each side, one fairly low and one higher up). Because the boy is small, we were photographing him playing. He was running around and jumping, so we needed a broad expanse of evenly lit white background. We also shot from somewhat farther back than normal to allow us to capture him wherever he was without taking the time to move the camera. In this particular image, the parent wanted us to crop in tight. However, the image works better with the additional room around him. We sense the space into which he is about to launch himself and we remember that he's just a little kid.

Lighting options for kids and adults are the same. How we entice expression will differ.

LIGHT METERS

Do we need light meters? When set in Auto mode, today's cameras do a great job of figuring out exposure. However, as we start to use multiple-flash techniques, a meter is really helpful. As in the portraits with the white background, we could just point the flash at the background and then do a bunch of test shots until the lighting ratio is what we want. It is better, however, to use a meter to determine how much light is falling on the subject and then how much is on the background. This method is much more efficient.

With high key, watch out for flare, which is where the edges of the subject start to soften. This comes from the subject being too close to the background, the light on the background being too intense, or the background light spilling onto the subject. If the latter is the cause, gobos can help.

No matter which style you go for, vary the contrast between your lights. No two faces react the same way. Customize for each.

The wrinkle

Some people are proud of their time-earned wrinkles; others aren't. With both high and low key, the placement of the main light and the power of the fill light in relation to the main will affect how the skin texture appears. The more even the two lights are, the more the shadows of the wrinkles are filled in and thus appear flatter and less noticeable.

Sometimes we want more dramatic lighting, but we still want to minimize the wrinkles. Soft focus filters are an option. There are various commercially made filters to choose from. Some will screw directly onto the lens, others slip into a lens hood. Some diffuse so slightly that it is nearly impossible to tell that any softening has occurred. Some are so strong that it almost looks like the photo is out of focus. If we are on a budget, we can make our own.

A bit of clear plastic that you can hold directly in front of the lens can work. Experiment with different types of plastic. Some will soften more than others. Just be aware that they diffuse the *entire* image.

These soft focus filters work by diffusing or scattering strong light, causing the edges to become soft. In other words, these filters affect how your lighting is recorded. The effect of your lighting is changed as it is recorded by the camera. It is a matter of taste as to how much diffusion is used. These filters can create wonderful moody images. For many photographers in this digital age, however, the fact that they diffuse the entire image is a drawback.

In the old days of film, portrait photographers would often use a tiny, tiny brush and photographic dyes to delicately outline the eyeball and draw over the eyelashes to sharpen up these portions of the image. If the eyes appear sharp, the viewer sees the photo as sharp, even if everything else is a bit soft. Today, with the focus on digital prints, we can still sharpen images by using leftover ink in our inkjet cartridges instead of photographic dyes. In truth, however, most of us today opt for using Photoshop's considerable capabilities to selectively sharpen and blur. This gives us the best of both worlds.

However, keep in mind that the sitter may be taken aback when looking at really sharp images. The photographer choosing not to use a soft focus filter on older subjects will need good communication skills when using this approach and should have samples showing before and after retouching *before* presenting unretouched images to the subject.

Eyeglasses and lighting: Can they get along?

Eyeglasses have long been a bane to photographers. The sun or our flash gets reflected in them and we lose important facial detail. We can't always get rid of the entire reflection, but it is worth at least trying to minimize it. Regardless of whether the light source is the sun or flash, the same tips will help.

The most obvious and easiest solution to eyeglass glare is to have the sitter remove the glasses (but you might have to retouch the marks from the nose pads). Once in a while you get lucky and a sitter will have borrowed frames without lenses from an optometrist. Either solution is great but not something you can count on. So we'll assume people are going to keep their glasses on.

More and more people have antiglare coating on their glasses these days. Regular glasses will give us white reflections. Those with the antiglare coating will give us pink or green. Either way, we'd like to keep the reflections to a minimum.

Tip: If your subjects remove their glasses, speak a little louder. This doesn't mean scream at your subject! However, people "hear" better when they can see properly. Some of our hearing (even for those with normal hearing) is actually enhanced by some unconscious lip-reading.

Antiglare-coated lenses are also subject to deterioration over time, which leaves the lenses spotty looking. Unfortunately, there isn't anything you can do. The spotting will show in the photo. No amount of cleaning will correct this problem.

In the photo on page 128, we've got the classic case of glare on the glasses. In the photo on page 129, there is none. All we did was have the sitter lower her chin. This works in a great many cases. Watch out for double chins forming, though. If they do, try having the sitter lean a little forward a little, or ask the subject to stretch his or her chin out a little bit. Often this gets rid of the double chin or at least minimizes it.

If these corrections don't work, try tipping the glasses a tiny bit so they sit a little higher behind the ear. You can only tip a *little bit* or your subject will look like a dork. Be aware that some glasses tip better than others. Metal frames seem to grip better. Plastic frames tend to just slide back down. The tilt must be very slight—just enough to help with the glare; not so much that it is evident to the viewer.

Another option is to raise the lights. This solution is generally quite successful. However, be careful not to raise the lights so much that ugly shadows start showing up under the subject's chin. Occasionally a compromise is in order and a small amount of reflection will remain in an upper corner of the glasses. Most professional photographers will retouch this reflection out of the images that are ordered. By keeping any glare as small as possible, the retouching will be easier and faster.

A last option is that you can also consider posing your subject with broad lighting. Because the body is facing away from the main light, the glasses won't present a problem. However, this lighting is rather flat on the face and not always the most flattering.

Transition lenses present an added difficulty. These lenses darken when exposed to bright light and turn into sunglasses. Unfortunately, the only answer is to pause the sitting periodically and have the sitter put the glasses in a pocket or purse or other dark place and wait for the discoloration to go away.

Groups

For a couple or a small family, we can still use lighting rather like we've done earlier in low key portraits. However, as the group gets larger, we'll need to amend the lighting. If we don't, we'll get an image where some of the people are well lit and the others are in deep shadow.

In the photo on page 132, the lighting is too contrasty. With just one light in a large umbrella (could be a window), we lose detail in the girl on the right and we've got intrusive shadows, particularly the shadow cast by the father onto the daughter on the left.

In the subsequent photo on page 133, we moved our light so that it was placed almost in front of the group, just barely to the right of the camera. Because we were shooting in a large studio, we also placed a large piece of foam board at the left of the group. Had we been using window light, we would have had to change where the people were placed to get the same effect. If we were shooting in a smaller room with white walls, the foam board would likely not be needed.

In postproduction, we also vignetted around the outer edges, so the focus is directed to the faces and the bodies aren't abruptly cut off.

By aligning the people roughly in a line, very little depth of field is needed to keep everyone in focus, and therefore we don't need multiple lights or tons of power.

The larger the group, the more even the lighting needs to be.

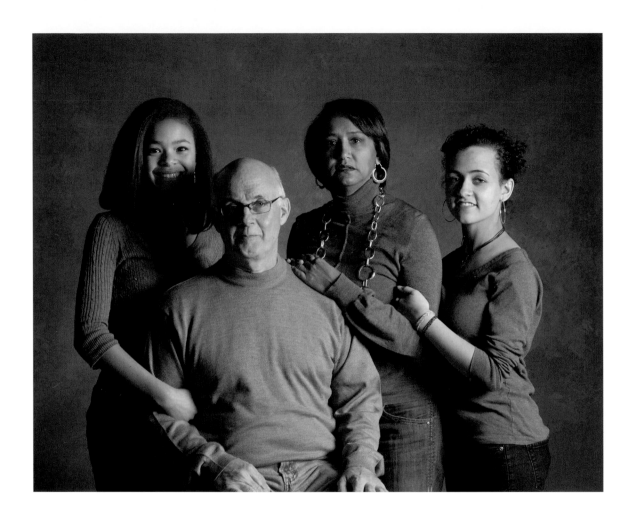

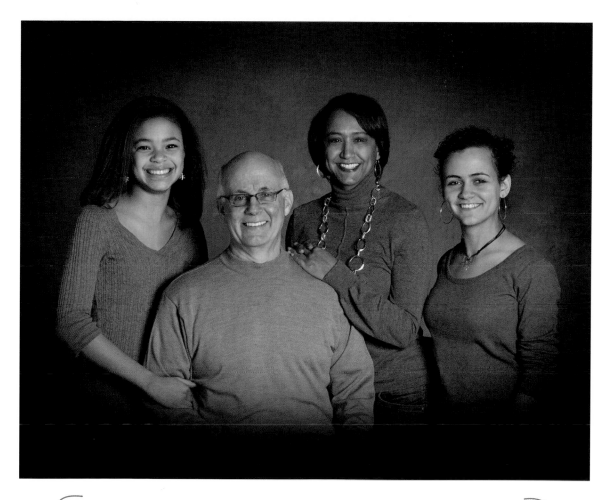

By posing the people so they are facing slightly into the center, we can pose them closer together, thereby being able to use a smaller background. It also tends to have a slimming effect.

When photographing large groups, where some people are on the ground, some seated, and perhaps several rows of people standing (on risers or stairs), we'd prefer to shoot from a higher viewpoint. By placing the camera at the same angle as the rows of heads create (by looking at the group from the side), it means that we can use a fairly small f-stop (and need less lighting power) and yet all the faces will be in focus. This approach has the added benefit that all the heads will be the same size. If the camera is simply pointed at a large group from standing level, the faces in the front will be larger than those in the back.

Hey, this makes sense because by shooting straight on, the people at the back are indeed farther away and therefore smaller. So if you know ahead of time that you'll be shooting a large group, be prepared to bring a ladder! If it's a surprise to you, then at least try to stand on a chair or find high ground.

Pets

Pet portraiture can be challenging. While dogs may understand commands like "Sit!" or "Down!" they don't understand, "Could you tilt your head a little to the left?" (And, in truth, even well-trained dogs tend to forget their commands when the flash goes off.) However, most dogs still look cute even when they aren't sure of their surroundings, and most tend to get used to the flash eventually.

Cats are generally tougher. Championship cats that are used to handling and the hustle and bustle of shows will sit regally and patiently for their portrait sitting. All the rest tend to try to back into a corner or make a beeline for the most inaccessible part of the studio. They look unhappy. Photographing them in their home or natural environment is generally easier than in a studio.

Although you can light animals just like people, it is better if you can angle a light to bring out the texture of their fur or skin (think lizard or snake).

As with any portrait, a head shot is easier than a whole-body shot. Because personality comes from

the face—whether human or animal, it's a good place to start. Like with people, if the animal is mostly dark, use a darker background; if it's mostly light, go with a lighter background. So many pet owners with a black dog come in wanting a white background thinking it's the only

Give the pet time to get to know you and to recognize that you're not the vet.

way they can get an image of the dark fur. The reverse is the better way to go. If the pet is multi-colored, then we might opt for a medium background or pick a background color that is similar in density (darkness, not necessarily color) to the most dominant color of the pet.

The photo on the previous page is a classic "head-and-shoulders" portrait that just happens to be of a dog. We used a main light in a softbox, a fill light (in-camera flash), and a third flash placed to the dog's left side (camera right). It's this side lighting that brings out the texture in the dog's fur.

In this case, we used black seamless paper as a background. Some dogs find the surface slippery, in which case you could use black cloth. With seamless, you can just brush off any shed fur or cut off the used seamless. With material, it is obviously more work to get rid of any shed fur.

So opt for seamless, if you can. Of course, if you are just aiming to do a head-and-shoulders shot, you don't need to extend the background under the animal and the slickness of the seamless won't be a concern.

The photo with the white background on page 136 is a simple pet profile. As with the earlier pet portrait, we used a main light,

the popup, and the accent light. We also had a flash on the white background. If you don't have the extra light, the background simply won't be as bright, but that would be okay.

Having the pet owner in the room with you is generally very helpful. First of all, it tends to calm the animal. The owner can help place the pet where you want it

and to keep the pet there. In this particular case, the owner was standing in front of the dog and getting ready to give the dog a treat. The dog naturally looked up, and the photo was captured with the eyes engaged and the tilt of the head that gives the image life.

It's a good idea to crop more loosely in the camera when shooting animals. Even the

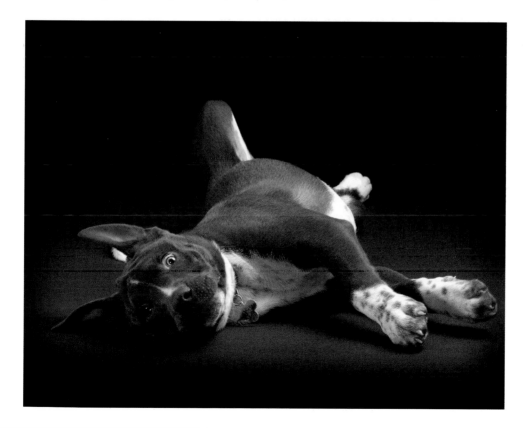

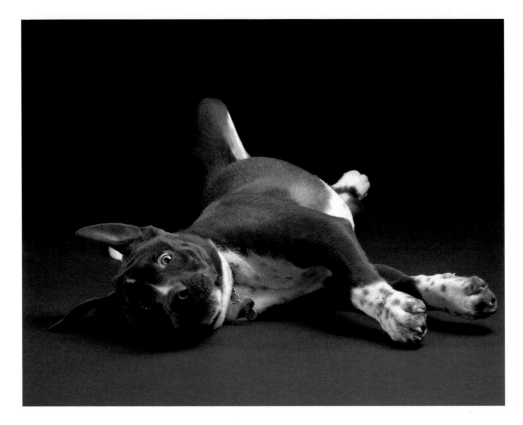

best-behaved pets rarely sit as still as people do. This way, if the pet moves, which is likely, the pet's tail or ear won't be out of the frame. Plan on cropping the photograph in postproduction, if warranted.

In the image on page 137, we have a photo of the dog's entire body. We wanted to capture the liveliness of the puppy. We left a lot of room in the frame. We knew this dog wasn't going to sit still. We had the owner rub the puppy's belly and then pull the hand away. We had no way of knowing exactly how the puppy would move. The lighting had to cover enough space to allow for this movement and still keep the dog well lit, wherever he went. We also had to have enough light to get enough depth of field to keep the body in focus and still shoot at a short exposure in order to freeze the motion.

Once the favorite photo was selected, we cropped the image and then did some postproduction work in Photoshop to burn (darken) the edges to focus the attention on the dog. Viewers of this photo often think the

overhead lighting was done with a snoot, but it wasn't. The flash was combined with a silver umbrella. As you can see in the photo on the facing page, which is the image as shot, without the edge burning, the light was not nearly so concentrated.

Ah, cats. Delightful little buggers. Handsome, sleek, mysterious, but not known for their cooperation. Working in a studio, you want to try to confine the space available to them. As we indicated earlier, they are much easier to photograph in their own environment. Either way, the lighting approach is the same, except that if you are in the home, you can make use of existing light (assuming your studio doesn't have a lot of natural light streaming in). If you missed it, return to Chapter 5 for an example of using just daylight and a fill card to photograph a cat.

If you're asked to photograph a snake, ask the owner not to feed it just before the sitting. It will just sleep. Tame goats are hard to find. Ferrets are great fun, but, boy, are they fast. So are mice. You'll need a lot of patience with these guys.

Chapter 7: So, Where Do We Put This Light for Metal?

Oh, no! Metal! It's really hard to shoot, right? It's reflective. It shines. It gets ugly highlights. The surprising news is that it can be easy to shoot, and we don't need elaborate equipment to get the photos right.

It's important to understand that almost anything reflects light in two dramatically different ways, and a good photographer *must* understand both of them.

Diffuse reflection means light coming from one direction reflects equally in *all* directions. Nothing produces perfect diffuse reflection, but ordinary nonglossy white paper comes pretty close. Take a piece of paper right now and turn it in different directions. Under many lighting conditions you will see that the brightness of the paper changes very little as you change the angle.

Bright metal produces almost nothing but direct reflection. *Direct* reflection happens in *only one direction*, and that direction is the opposite of the angle at which the light strikes it. Now pick up a piece of flat, bright, unpainted metal. (You may have to go to the kitchen and find a metal spatula or tear off a piece of aluminum foil.) Turn that metal just as you did the paper. Depending on the room lighting, you may see the metal turn from completely bright to completely black with a slight turn in angle. Even if the lighting in your kitchen does not produce the dramatic effect we describe here, you will certainly see a substantial difference.

Direct reflection means that the light reflects from the surface at exactly the same angle, but in the opposite direction from wherever the light comes. That means that we can only see the light from one direction; we have to look at the subject from exactly the proper angle. If we don't want to move the camera to that angle, then we have to move the light to make that angle. If the angles don't line up, we can light the metal with 40,000 gazillion watt-seconds (or joules, for most of you non-Americans), and the metal will still be absolutely black.

In fact, without capitalizing on the proper angles, that metal will stay black until we give it enough light to heat it until it glows on its own. That won't happen though; we'll be running to call the firefighters long before that.

So we put the light in the right place so that it reflects brightly from the metal to the camera, and God says, "Let there be light," and certainly, there is light. Furthermore, the light may be surprisingly bright, even with a very tiny, very low-power flash.

Done deal? No, not yet. So far we've only lit the metal from one angle. That's fine if the metal is microscopically small, but most metal is bigger than that. It doesn't just reflect light from one angle but from a *family of angles*. Each point on the metal needs to be lit from a different place if we want the metal to be uniformly bright all over. Usually we don't want the metal to be uniformly bright; instead we want some dark areas to define the shape. Still, we want our bright area to be pretty big.

Polished metal produces mostly *unpolarized* direct reflection. You can quickly see where the problems are. The real decision is to determine how bright you want the metal to be. For the most part, you will want it to be bright with some texture, but that is an individual decision.

We *do* wish someone would come up with a shorter, more elegant term for "family of angles." Still, no one has since one of your co-authors, Fil, invented the term a few decades ago. It's now used in physics, astronomy, and even chemistry. Come on, people, think up a simpler word! Any language will do, but we hope it transliterates reasonably into English.

The first step is to figure out where the family of angles is. Because direct reflection only occurs within a small family of angles, the choice of where to put the light is limited. This actually makes it easier for the photographer to get it right quickly. The placement of the light and the camera in relation to the metal is automatically limited. If you want a specific camera viewpoint, then as you'll see, the light placement is fairly predetermined.

Start by placing your diffusion material behind the subject. Point a simple test light (it could be a flashlight) at the metal from the camera position. You'd like the light source to be narrow enough to illuminate the metal and not the surrounding elements. Point it to the portion of the metal that you want to light and note where the light is bounced back to your diffusion material. If your light source is small, you may need to point to the top part first; note where it reflects back onto the diffusion material. Then move to the bottom and do the same.

Assuming you want bright metal, your main light will have to be placed so it completely fills this family of angles. If it doesn't, you will either get dark or uneven lighting. If you are aiming for dark metal, your light has to be placed outside of the family of angles. Simple as that.

Don't fear metal! It's actually pretty straightforward.

Flat metal

The image below was lit with the off-camera flash behind the saw without diffusion. The in-camera flash was used as fill. The handle is okay, but the blade is very dark. The shadows are big and sharply defined. Not very good, is it?

In the image at top left on the facing page, we put a white reflector to the left of the saw, which brightens both the blade and the shadows, but the blade still isn't the shiny metal we expect.

In the photo top right (page 145), we added a framed diffuser between the saw and the off-camera (main light) flash. It was almost vertical but angled slightly toward the saw. The metal is starting to get brighter. Progress!

Although there are times when we want the light to fall off, this isn't one of them. We need to make our main light source bigger if we want the metal to be consistently bright. We've already been using diffusion material, so what's wrong? We need to angle the

diffusion sheet on a *steeper* angle so that the top of the framed diffuser is just barely outside the camera's view. By doing so, we are now lighting all the metal's family of angles so the blade will now be bright. There was no change in the light's position in this case. The image bottom left (page 145) shows the result of this steeper angle.

The blade now is bright (but not white) and still has detail. We could stop here. However, in the photo bottom right (page 145),

we went ahead and put back the reflectors we used earlier. This softens the shadows even more and we get more detail there as well. The shadows are also less distracting.

Now compare the photo at the bottom right on page 145 with the image at the beginning of the chapter. They are almost identical. However, we opted to put a gobo between the diffusion material and the saw. In this case, the gobo was black mat board cut as wide as what was seen in the camera and only a couple of inches high. It blocks hardly any light at all, but by using it we got a bit more definition of the shape of the handle at its upper edge. It's a small point.

Use a long lens when possible. You'll have more flexibility in light placement.

Moving your light closer makes it a bigger light source. It makes the background brighter, but it won't affect the brightness of the metal. In reverse, move the light farther away, and the background will get darker with no change in the brightness of the metal. Neat, huh?

Round metal

Just as with flat metal, we are going to need a large light source to handle round metal. Because it is round, the angles of reflection are increased. So our placement of light needs to change. We'll start with little lights and then turn them into larger lights, step by step. The difference in the light quality really shows up with a shiny, brushed-metal peppermill. It's not a new one, as you'll see in the early shots. Although it's clean, it's clearly used. By the time we get to using big lights, those flaws are gone!

We started with an off-camera flash with no diffusion at camera right (main light) and deflected the in-camera flash so none of its light struck the subject but merely triggered the off-camera flash. Result? Ugly shadows and metal.

We removed the board blocking the in-camera flash and allowed it to be a fill light. No neutral density material was used in front of the fill light. The shadows improve, but the metal is worse. We've now got a truly ugly highlight in the middle of the peppermill.

Two changes here. We added a white reflector at camera left and put some neutral density material in front of the fill light. The peppermill is now shiny metal on one side and the ugly highlight in the middle is also improved.

We added diffusion material in front of the off-camera flash. This simple act gets us a large light source. The highlights on the vegetables are softer and more pleasing. The peppermill now has a fully rounded shape and brightness on both sides. Note, too, the change in the shadows, especially on the flowerpot.

A LAST TOUCH

We could have stopped at the previous image, but by attaching a small piece of white board to a dowel (clamped to a light stand) and angling it to reflect in the top of the pep- permill, we are able to brighten the top of the peppermill and give it more definition as well.

When using a reflector, get in the habit of clamping it to an angle iron or light stand when possible. If you don't, the reflector can fall over and move items that have been carefully placed or, worse, damage items.

Chapter 8: So, Where Do We Put This Light for Glass?

GLASS IS GENERALLY considered hard to shoot. How do you capture an image of something that is transparent?

In truth, glass is more challenging than metal. Light travels through the glass and isn't reflected back to the viewer (camera). At the same time, it will have unwanted reflections of its surroundings. Like metal, most of the reflections are indeed direct reflections. However, with glass the reflections can also be polarized. The photographer needs to pay attention to the edges, which will give the glass form. The rest is not of much concern.

When the light strikes a visible edge of glass, it is not reflected back to the viewer (camera). Hence, it disappears. We need large reflections, distinct enough that the viewer can discern the shape of the glass clearly. For this to occur, we need the reflections to be different from the background. The choices are dark-field or bright-field lighting.

With practice, you can enjoy photographing glass!

Dark-field lighting

Dark-field lighting is where there is a dark background and therefore glass needs bright lines to outline the shape of the glass with no other distracting light at any other point. These bright outlines tell us where the glass starts and stops.

The good news is you don't need a lot of lights, nor even big ones, to make good photographs of glass. Well, actually you do need at least one large light, but by now you know you can create a big light out of your off-camera flash!

Place your main light (your off-camera flash) behind and above the glass. You can either aim the off-camera flash at a white wall behind the glass or point the light toward the glass but with a diffusion sheet between the flash and the glass. Either way, you now have a large light source, critical to doing this type of photograph.

Next place a dark card (gobo) between the main light and the glass. This card needs to be smaller than the light source. If you are shooting at the white wall, you can clamp the card behind the light to a light stand. If you are shooting through diffusion, you can attach the board to the diffusion material directly, or again clamp it to a light stand. (If you don't have an extra light stand, you could hang the card from above with string.) The exact size of the black background isn't critical. It simply has to be small enough that sufficient light gets around it.

Glass on black Plexiglas with black seamless behind the glass. This image was lit by using undiffused off-camera flash (camera right) and undiffused in-camera flash as fill. Not very good, is it?

Position the camera so the viewfinder is exactly filled by the background. This is important. If the background extends beyond what the camera is seeing, it will block the very light that will give definition to the edges of the glass.

At this point you can move the glass to the point you prefer. You'll get sharper edges as you move the glass closer to the camera. In the image below, the glass now has simple, elegant definition.

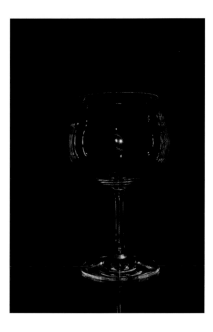

We got rid of the shadow by replacing the black seamless with black velvet. (You could also just move the seamless farther back, if you have the room.) Unfortunately, all the other problems remain.

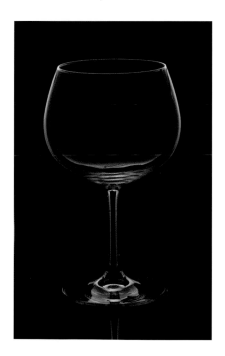

Clean glass meticulously. Any smudges, fingerprints, or watermarks will show up and have to be retouched afterward! So to avoid retouching, clean, clean, clean.

Bright-field lighting

Bright-field lighting is, as you would expect, where you have a bright background and the glass therefore needs dark outlines to provide shape to the glass.

Set up a light-colored background. This could be diffusion material, light seamless, a shower curtain, tracing paper, cloth, or a white card or wall). Place a light so that it lights the background evenly. If you are using translucent material, you will place the light behind the background and point it toward the glass. If you are using opaque material, you will point the light at the background and let the light bounce back to the glass. If you use this latter approach, you need to be careful where you put the light so that it does not reflect in the glass!

Set up the camera so that the viewfinder is exactly filled by the background. If the lit background is too big, you can make it right by adding black cards to each side so you get the viewfinder filled correctly—no more, no less. If you are using a white card, as opposed to a large white wall, and the field is too big, you could use a smaller card.

You can now move the glass forward and back until it is the size you want. As you bring the glass closer, the edges will be more defined because less light will be reflected on it.

So how do we fix the truly ugly image below? We need to both brighten the glass and get dark outlines. Because we used white diffusion material as a background, attach black cards directly to the material. (If the background were a white wall,

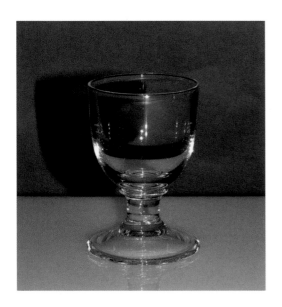

Glass is placed on white Plexiglas, but you could use any light-colored background. Behind the glass is white diffusion material, but it could just as well be a white wall. Photographed with just the in-camera flash (with no neutral density material), we get a glass with no definition and we've got one really ugly shadow.

we could have hung them with string or attached them to light stands.) The placement of these black cards is important.

Because we have diffusion material behind the glass, we next place our off-camera flash behind the diffusion material. If you are using a white wall, point your light at the wall instead. You will need to use a boom in order to get the light placed correctly in this case, because if it is on a light stand behind the glass, it will show in the photograph. Because we are using the diffusion sheet, the light is hidden and we can use a light stand easily.

Place the camera so the background exactly fills the camera's field of view. If background area (the lighted part) is too large, we can use black cards to reduce its size.

In the image below, we now add the off-camera flash behind the diffusion sheet. This causes substantial improvement. There are, however, still distracting small highlights from the undiffused popup flash.

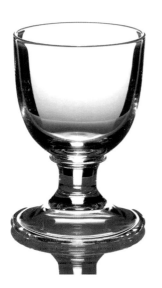

Glass with off-camera flash behind diffusion material and pointed at glass. An in-camera flash was used without neutral density material. Black cards were used to limit the size of the background. This setup improved glass definition and brightness.

LITTLE THINGS MATTER

In the photo on the left on page 156, we added neutral density material in front of the in-camera flash. By diffusing this light and dimming it, we got rid of the distracting little speckles of light seen in the photo at left. Because our black boards were carefully placed, we have good edge definition while keeping the glass bright. For comparison, note how the edges change when the black cards are placed too far apart in the photo on the right (page 156). The edges lose their detail, especially at the rim and the base of the glass. So bring the cards in closer as we did in the previous photograph or use a smaller white board, if you're using that instead of diffusion material.

Here the black
boards were moved
so the background
was bigger. We
lose the good edge
definition.

A glass half full

Interesting things happen when you add liquid to a glass. By adding liquid, the glass takes on qualities of a lens. It starts to see things around it and the liquid allows these things to become visible. In the photo below, we have a small white board behind the glass. It is far enough away that we can have the off-camera flash light the board. We used barn doors to block the light from the flash from lighting the glass.

The board is just big enough that when we look through the viewfinder, we see white all around the glass, but just barely. Even though we have a board that fills the viewfinder, the liquid is seeing the room around it.

The liquid is acting as a lens and showing us the surroundings even though there is a white board behind the glass that is big enough to fill the viewfinder with white from edge to edge.

THE FIX

We might be inclined to simply use a bigger white board. That will certainly do, but the edges of the glass will be not as well defined as we'd like. The better solution is to keep the small board but move the camera closer and, if necessary, change to a shorter lens to get a comparably sized image. This way the background fills the liquid portion of the glass more pleasingly and retains good edge definition. In the photo on page 158, we switched to a shorter lens and moved the camera to get a similar position as in the photo on this page.

With the use of the shorter lens, there will be some distortion. Look at the top of the wineglass in both images of this glass. The shape of the lip is deeper in the short lens version. This is rarely a problem.

Glass and paper

At this point, we've learned that we need diffused light more often than not. So we'll start this exercise using diffusion material between the main light and the bottle, placed to the right of the bottle. Our challenge here is to get good lighting on the glass bottle but also retain good definition in the paper label.

Bottle lit with off-camera flash through diffusion material. In-camera flash is used with neutral density material. We get a soft highlight on the bottle, but the label is too dark on one side and too light on the other.

By adding a white reflector to the left of the bottle, we've improved the left side of the label and added dimension to the wine bottle. The right side of the bottle is okay, but the label still lacks definition.

The final element is to add a gobo (black card) to the right of the label. It needs to be just tall and wide enough to block some of the light from the off-camera flash so that the label is now legible and both sides are evenly lit. We sacrifice some of the highlight on the bottle, but this is acceptable, as we still have a highlight and shape to the bottle.

Bottles and more

The final image in this chapter will incorporate a bottle, a glass with wine, grapes, and an old wooden corkscrew. We need to keep the bottle and glass transparent while retaining definition of the glass, the label's legibility, and avoiding unwanted glare on the corkscrew.

Although we can do this with just two lights, this is one of those times where we'd prefer to have a few more. So if you can, rent or borrow two more lights and stands.

Our background is white seamless paper. The main light (off-camera) flash is placed to the right of the bottle. In the photo on page 161, we omitted any

diffusion material between the off-camera flash and the setup. We are using enough neutral density filtering on the popup flash to balance the light pleasingly. We know from the previous series of photographs that a reflector is likely to be helpful, so we've included it here to the left of the setup. You can see

it reflected in the bottle. In this case, we also have an overhead light on a boom behind the subjects, which is aiming at the subjects, and we have a single light on the background (camera right), lighting fairly evenly but allowing a little drop-off at the far (left) side. (If we wanted an evenly lit background, we could have placed the background light on an additional boom or we could have used an additional background light on the left.)

In the photo at left on page 162, we added diffusion material between the main light and the setup. We get a better highlight on the bottle. In the photo at right (page 162), we moved the off-camera flash *farther* away from the diffusion material. As a result, we get a larger and softer-edged highlight on the bottle. Assuming we have a flash with adjustable power, we will want to up the power a little to compensate for the light being farther away. If your flash has only one power, you'll need to lessen the amount of neutral density material on the on-camera flash to keep the light nicely balanced. You may then need to amend your f-stop to maintain good exposure.

Without diffusion material, the highlights on the bottle are too small to give us a good sense of the bottle's shape.

So far, so good. But we're missing something hugely important here, and that's what we mean by *diffusion*. Diffused light means the photographer scatters the light into many different directions at once. *Diffused reflection* means that the subject reflects the light in many directions. Imagine nonglossy white paper. Diffused *light* means that the light strikes the subject from many directions.

Diffused lights are *always* big lights, at least compared to the size of the subject. Putting a piece of translucent plastic over our flash diffuses it a little. Hanging a large piece of the same material a few feet in front of the light diffuses it much more. As far as the subject can see, the big diffusion sheet *is* the light, not our tiny little flash.

LIGHT PLACEMENT MATTERS

As we've seen, placing the main light farther away from the diffusion material makes a more pleasing highlight on the bottle. But raising the light a bit gives us a highlight that runs the length of the bottle instead of in bits. It's a very small change but an important one.

Chapter 9: Motion

OKAY, WE WANT to shoot a picture of something that isn't holding still. Sometimes we want to freeze everything. To do that, we can just use a really fast shutter speed. We have to compensate for the faster shutter speed either by opening up our f-stop or by increasing our ISO. Often, though, we want to capture some (or a lot!) of that motion.

A bit of motion

In the image at left on page 166 is a clear-cut example of the second case. Who would ever want to photograph fireworks without motion? The only piece of equipment we need beyond the camera is a tripod. (Okay, some photographers are better than others at leaning on something static and holding acceptably still, but "acceptably" is subjective—better photographers are tougher judges on what is acceptable.) The only light was provided by the fireworks and the jetty lights. There is no one right exposure setting for this type of image. You'll have to experiment with the shutter speed and the f-stop to get the exposure right and freeze the fireworks as much as suits you.

In the photo of the dancer (page 166), we have a dancer jumping. In this case, the photographer used white seamless as a background. A flash was camera right. No reflector or additional light was used. Despite all the times we usually try to lighten, soften, or minimize a shadow, sometimes it can be an active part of the image.

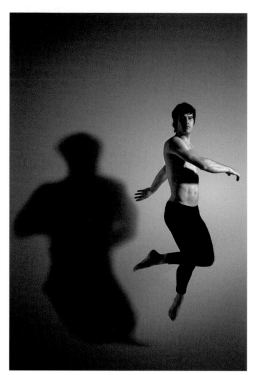

Quartz-halogen

Quartz-halogen lights are good tools for photographers who often shoot motion. They have ordinary tungsten filaments, but the glass has some quartz, unlike ordinary silicon-based glass. The inside of the lamp is filled with an inert halogen gas, which keeps the filament from oxidizing (burning up!). They typically produce about 60% to 70% more light than ordinary tungsten lights of the same wattage. Usually more expensive than ordinary household tungsten, but much less expensive than flash, these *continuous* lights are always on. The fact that they don't flash allows seeing motion over whatever exposure time we choose.

Lots of motion

Sometimes we actually want a lot of motion. In the photo below, we wanted a photograph that conveyed activity. To accomplish this, we need a continuous light source—could be sunlight, quartz-halogen, or a house lamp with a tungsten bulb. You'll have to set your camera to a longer exposure. How long? That depends on the brightness of the light source *and* the speed of the motion. For a ballroom dancer, we may decide that $\frac{1}{30}$ second is too short; for a bullet emerging from a pistol barrel, $\frac{1}{1000}$ of a second is way too long. The trick is to get your timing down for when you fire your flash. (Note: If you're using a house lamp, you'll probably need several for a shot encompassing this much space.) The room had very little ambient light. We set up a hot light at camera left. Our off-camera flash was placed behind the loom pretty much directly in front of the camera. The flash was high enough and angled so it lit the foreground. Our in-camera flash was covered with a bit of neutral density material. We attached a cable release to the camera and a homemade trigger to the off-camera flash (long enough to reach from the flash to the photographer). We locked open the shutter with the cable release, letting the motion be recorded, and triggered the flash when we thought the hands were in the right place; then we unlocked the cable release to end the exposure.

TUNGSTEN

As we write this, we have little prediction of the future of tungsten lighting. Existing laws will prohibit manufacture within a few years in the United States, but the definition of "few years" could be modified. Other countries have laws that don't specifically prohibit tungsten but prescribe energy-efficiency standards. Can tungsten lighting be improved to meet those standards? We don't know. Whatever happens, there *are* good alternatives to tungsten, but they may be more expensive or may offer inferior color. When we say "tungsten," adapt your thinking to whatever is available when and where you read this.

A homemade flash trigger. We make one from whatever connector fits the flash; the other end is a piece of plastic tubing (from a hardware store) fitted with any sort of push button switch that fits (from an electronics supply store or maybe a hardware store). This allows us to manually trigger the flash at any point during the overall exposure, which is especially good if we're musicians or video gamers with quick hands!

In the images on this and the next page, we approached a motion shot somewhat differently. In this case, we simply wanted hands moving through space. We had a black seamless background set up a long, long way from where the sitter and our lights were. We wanted the background to be absolutely black. (If we don't have a space big enough to allow this, we can change the background to black velvet.)

We again had a continuous tungsten light source. We had a flash positioned to the side so it would hit the hand not straight on, thereby giving shape to the hand. No other lights were on in the room except for the one tungsten light source. The flash was attached to a synch cord but not attached to the camera. With the camera on a tripod, we locked the camera lens open using a cable release, told the subject to move his hand, and then triggered the flash by putting a straightened-out paper clip into the synch cord. In this case, we wanted the motion to come first and finish with the hand in

the gesture we were aiming to capture. Upon firing the flash, we unlocked the cable release and the image was captured.

Admittedly, the photographer often wishes he or she had a few more hands to complete this process. It takes a bit of practice, but it actually isn't too hard. Some photographers will get

a friend (assistant) to help out by having the friend handle the locking and unlocking of the lens. The photographer will always retain the decision of when to fire the flash. But the truth is, you can do this by yourself. The harder part is to get the timing of the flash correct.

These photos are of a pianist known for his lightning fast fingers and particular hand gestures. He wore black clothing. We also covered his upper arm in black velvet to be sure the hands would float in space.

We shot lots of versions, with different hand gestures, and in each case we had to do our best to time the firing of the flash at the end point of the motion to get the fingers where we wanted them. (If you want to hear what these hands can do, go to joshuarich.com!)

Manual triggering without *any* special equipment

Need to manually trigger the flash? Don't have a specially made external trigger? Use the simplest synch cord the flash allows (ideally only two terminals). Unplug the camera end of the cable and stick in a bent paper clip when you want the flash. This is safe for simple camera-to-strobe connections, because we use very low-voltage signals to protect the shutter. It is *not* safe for other higher-voltage electrical circuits.

One warning, though: if we have a complex flash cable, we may not know which two terminals make the trigger circuit. Conceivably, we could damage the flash by connecting the wrong terminals, even though we stand no chance of damaging ourselves. That's why we suggest a *simple* synch cord with only two terminals for this procedure. Most flashes will accept such a cord.

Freezing motion

We can shoot this photo of a strawberry splash manually. Musicians and athletes are probably better at this. Galileo, a professional-caliber musician, sang to time his gravitational acceleration experiments. Every sprinter knows the rhythm of the start count beginning with "on your mark." Paul Fuqua, one of Fil's co-authors on *Light—Science & Magic,* and Fil, one of the co-authors of this book, once captured a bullet emerging from a pistol with a "one, two, three" count. Anyone can do this without any new equipment. Still, if we have a special interest in freezing motion and want to do this over and over, electronic devices are more reliable. We'll talk about the more reliable, electronic way because that's the way this picture was done, but be assured that we can do the same thing with simple equipment—plus a lot more patience.

The image at right is not an easy one to capture. Think of this as inspiration. High-speed photography of this sort requires patience, and in this case a willingness to do some cleaning up afterward! Although it is possible to shoot this without additional equipment, we'd be relying on a lot of luck.

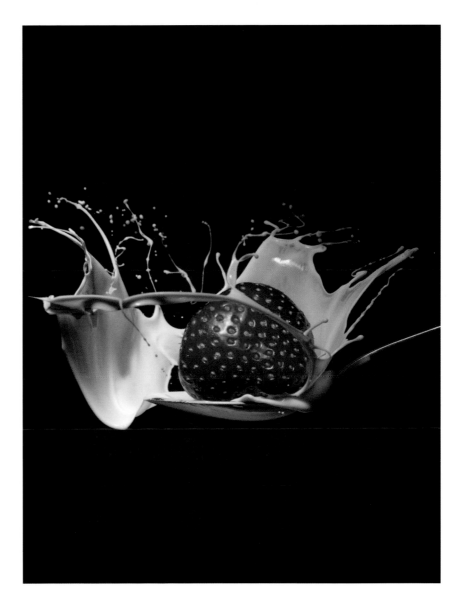

This picture uses two external flashes. Even though we're trying to use only one flash in this book, the picture is interesting enough that we want to talk about it. If the photographer had only one flash, he could have also made a good picture with only one flash on the subject, leaving the background black.

Here the photographer used an electronically controlled triggering system to fire the flash. There are different systems to trigger the flash based on light to detect motion or sound. The motion of the strawberry crossing an infrared beam triggers the flash.

The room needs to be completely dark. It takes a little experimentation to determine where the transmitter and receiver need to be placed, as well as the flash.

The spoon was taped to a clamp. The photographer put a red seamless background behind it. A flash with a red gel was pointed at the background. The background is far enough away from the spoon that it remains somewhat dark. The flash with the gel will brighten only the part of the background just behind the spoon.

A second flash was placed on a light stand camera left, with a grid to restrict the light to just the spoon. Several test shots were needed with the strawberry just resting on the spoon to determine exposure. In this case, the distance from the beam to the spoon was 9 inches.

The shutter was set to bulb. A wired cable release was used to do some test shots. (Here you can use a small flashlight to see what you're doing.) It will take some experimentation with the time delay on the triggering device to get the timing right. We're talking milliseconds here! Once we have the timing right, we're good to go.

After putting some cream into the spoon and locking the shutter open, the photographer dropped the strawberry. As the strawberry broke the infrared beam, it triggered the flash and the photographer immediately closed the shutter.

WHAT IS BULB?

Bulb is completely manual control of how long the shutter is open. The word once meant squeezing a rubber bulb to open and close the shutter, and, a hundred years ago, practiced photographers got pretty accurate shutter speeds this way. Today's photographers with amazingly accurate electronic shutters still use this manual control for longer shutter speeds.

An event like this happens so quickly that there's no way to immediately know if we have the shot we want. We have to look at the image and, almost always, shoot again. The pattern of the splashing cream is random, and it may take two shots or a hundred to get it right. In this case, the photographer dropped the strawberry by hand, in darkness, and frequently missed the spoon entirely! The great thing is that we no longer have to wait for the film to come back from the lab to find out when the picture is good.

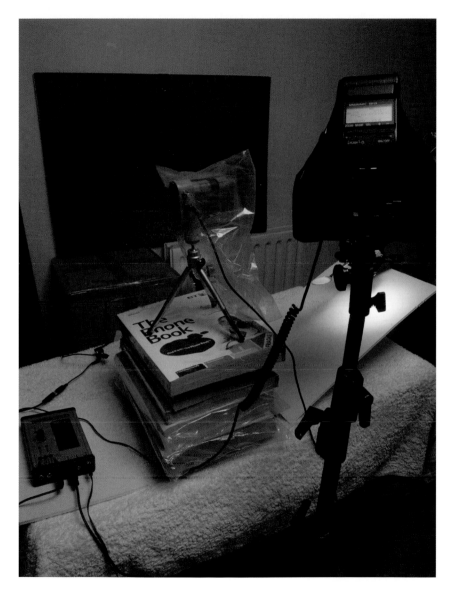

Setup for the image of the strawberry dropping into cream. Note the plastic over the camera, always a good idea when photographing in bad weather or when liquids are splashing nearby.

If you do photos like this one, be prepared for some cleanup afterward!

Chapter 10: The Future Is Now?

THE PRINCIPLES OF light remain the same, but the way we use it is ever changing. What we use and how we use it will continue to evolve. Flash and strobes will continue to get stronger, without necessarily getting bigger or more cumbersome; they'll get "smarter." Humans will continue to come up with innovative approaches to both the technical and artistic elements of photography. Here are a few new things to be aware of. Some will turn out to be very important, some will be passing fads. The best crystal balls are cloudy.

New light sources

Flashes will continue to get smarter. Whether this is an improvement waits to be seen. At the moment, intelligent flash hugely improves the chance of a novice photographer getting a good picture. Still, an experienced photographer needs to study a pretty thick book to use that flash to be *sure* the picture will be right. Once, we could pick up *any* flash and learn to use it in minutes, if we already understood the basic principles. Will the flash-camera intelligence combination ever be good enough that *anyone* can use the flash reliably without extensive study of each new piece of equipment? Certainly, but how soon?

Tungsten is one of the most beautiful light sources, but soon it may be illegal to manufacture it because of its energy inefficiency. Will there be an adequate replacement? Read on.

Fluorescent has traditionally been an awful light source because of its poor color and the inability to control the size. Nevertheless, fluorescent lamps have become dramatically smaller. (We can always make a small light bigger; we cannot always make a big one smaller.) The color is getting better, but most of them still have "spikes" in certain colors to compensate for lost color between those spikes. We see continuous improvement; your authors, Robin and Fil, now replace all used tungsten bulbs at home with compact fluorescent lamps, but we are not sure how long it will be before we want to use them for photography.

LEDs (light-emitting diodes) have a humble past. Originally designed for low-current displays in calculators and watches, they are becoming powerful—literally popping up everywhere, from our car taillights to (soon, perhaps by the time this book comes out) household bulbs. Photographers are *already*

combining these little lights on their own to make usable lighting for photographs. LEDs are really cheap. It doesn't take rocket science to join these little lights together, thereby creating a bigger light. Today their color isn't very pleasing for the most part, but that, too, is changing. (We can fix that current cool color with software, especially when we shoot in raw.) Depending on how many we hook together, we may just be able to light a small scene. The more that are joined together, the bigger the light and the stronger the light source. Something for the do-it-yourselfers to consider!

The photo at the beginning of the chapter uses LEDs as the light source for the image. It isn't your everyday setup, but, boy, is it fun. This photographer has a dryer atop a washing machine in her garage. She set the camera on a tripod in front of the dryer's open door. She powered on the washing machine, which turns on a lot of red LEDs. She used a mirror (under the camera) to reflect the red light into the dryer drum. She then turned off the light in the garage so it was *completely* dark. Finally, she made a time exposure. Done. Very cool. And what

was the result? Reflections of the little bumps inside the dryer. The technique was ever so simple, but it took someone with curiosity and a good eye to even think of shooting a picture like this.

Advanced sources include *HMI, HID, CDM,* and probably more to come. All of these are too expensive for hobbyists. (Therefore, for now, let's skip spelling out the acronyms.) *But wait!* More than 20 years ago, in another book, Fil wrote that HMI would probably never be affordable, even by professional standards. Fifteen years later he was asked to light a video about the major artifacts of a new museum and was given a generous assortment of HMI lights to use. The main job of a photographer is to have open eyes, not just for what's in front of us now but for what's to come.

Postproduction

The world of photography has always been fluid. We used to chase new and better film, cameras, lenses, and lights. Today, the film part is fading in use, although it has capabilities that digital is still working to match. Size matters: the bigger

the image, the more detail we record. Small digital sensors are affordable to all photographers, but the larger ones are affordable only to professionals with the highest profit margins. However, digital is here to stay and is improving in leaps and bounds. So now we chase new cameras with more megapixels, and better lenses and lights, and, in addition, software that lets us work with our images both more efficiently and with great creative capabilities.

Postproduction work has always been part of photography. Does post have anything to do with lighting? Should we even mention it in this book?

Yes, to both questions. There are things we can do either in lighting or in post, and the effect is about the same. Although there have been purists who insisted on nothing but "straight prints," most photographers for over a hundred years have insisted on darkroom work to improve their lighting. Which way do we want to get the job done? Shooting? Post? Whatever is easier and more efficient. It is incompetent to spend hours on the computer trying to fix something we should have shot right in the first place;

it is silly to spend hours to perfect lighting we could correct in a few minutes with digital tools.

The image we capture is seldom the final product. Should the image be cropped to make it more dynamic? Does it need color correction? Do portions need to be dodged (lightened) or burned (darkened) to draw the viewer's eye to a spot or away from it? Should we blur the image a bit or sharpen a portion?

Once, post was essential to *all* photography. We *had* to process the film. We *had* to make a print. While we were at it, why not make some improvements along the way. Now, with the right equipment, we can send our pictures directly from the camera to the printer, with no darkroom, no real computer, no adjustment.

In other words, no post. That's one of the biggest problems with novice photography today, but it's also one of the easiest problems to fix. Not everyone wants to invest in the most powerful computer or the latest version of Photoshop, nor should they. (Serious professionals should, however.) Still, most of us have computers now, and there is cheap or public

domain image editing software that, at a minimum, all photographers need to use in order to improve their lighting.

In the days of film and before software got involved, we would do much of this processing in the darkroom and then some additional work by hand, either retouching with brush and photographic dyes or airbrushing. Today, most of us—even when shooting film, which we then scan—make these changes using software. Adobe Photoshop is probably the best known, but there are others out there as well.

We can now take a photograph and make it look as if it was done in oils or watercolor. We have a wide range of papers with different textures. We can selectively blur portions of a portrait, while keeping the eyes and mouth sharp.

Ansel Adams not only shot images over and over again in the same spot seeking the perfect light and angle, but he also printed the negatives over and over again over the course of many years, making different decisions as how to best bring out his vision of the scene. As we age, we "see" things differently

(hopefully as a result of growing knowledge). Life experience influences our decisions. We need to fight getting stuck in a rut. Using the software available today is incredibly fun and helpful, and as a result it not only helps us create better images but also keeps our eye fresh.

The hardest part of using the software is knowing when to stop. If we simply use the computer to do the same things we used to do in the darkroom, fine. If we come up with a whole new image that never could have been done with any previous techniques, better. If we use standard digital filters to make a photograph look like, say, an impressionist painting, stop right now. Either get back to photography or go learn impressionist painting.

High dynamic range imaging

The best way to deal with a scene that has both extremely bright and extremely dark areas is to light it so that everything falls into the limited *dynamic range* of the camera. Still, sometimes we simply can't do that. We can't light a mountain above a valley. We may not even be able to light

a small room if it has a historic presence whose existing light already conveys a mood we can't easily duplicate with any number of portable flash units.

High dynamic range imaging, known as HDR or HDRI, is growing in capability and popularity. It is a method of shooting images primarily when we are faced with trying to take a photograph where the lighting range is too broad for the digital camera or film to handle in a single exposure—that is, we have too much light in one area and too little in another. Our eyes are so incredibly capable. We can walk outside on a bright sunny day and see perfectly well. We can also walk down a dimly lit corridor and manage just fine. It might take a moment for our eyes to adapt when going from a bright scene to a dim one, but they do it and do it quickly. Cameras handle different light levels much like the eye in that we can change the aperture of the camera's lens (just like the eye does on its own). However, cameras don't handle low light levels as well as our eyes do. Even with lots of megapixels, low-light images are likely to

have noise (see Chapter 4.) Our eyes also manage to see detail in shadows even when much of the scene is brightly lit. Cameras are not as forgiving.

Why can our eyes do this, while our cameras cannot? Actually, our eyes aren't as good as we think they are, but they're operated by a massively powerful computer—the brain—which weaves together the lightest and darkest areas to make a whole scene. Right now, we can't do this with our cameras: they are not yet smart enough. Still, we can now do it on our desktop. The computer we have may take a few seconds or a few hours, depending on the processing speed and the amount of RAM we've paid for. In either case, it can't match the fraction of a second our brain needs, but it can get the job done.

Normally when we want to take a photograph that has some portion in very bright light and another portion in deep shadow (and it's not a situation where we can add light to the shadowed area with our flash), we have to make a decision to sacrifice some portion of the image

and let it have no detail. This might be the sky or the inside of a treasure chest in the corner of the basement. Using HDRI, we no longer need to lose this information.

Now we can take the same photograph (on a tripod to avoid movement) over and over again, bracketing each exposure so we end up with the same image ranging from seriously overexposed to very underexposed. We then selectively join the best bits together. There is a variety of software out there that will allow us to blend the parts we want into a single image, thereby ending up with an image that has detail wherever we want it, in whatever amount we deem appropriate. Obviously, this works best with images that are static. However, the software is improving, and we now can add people to the images using this technique. It will still require some retouching after the blending, because people simply can't hold still well enough over the time it takes to capture multiple images. The software available today does a great job of blending the multiple images together, but we need to look carefully at edges and in

all likelihood do some selective retouching.

In the photo above, we have a dark exposure of a conference room. We have detail in the brighter elements of the room (like the lamp shades), but little detail in the darker areas. In the top photo on page 180, we have one of the lighter exposures of the same room. It has good detail in the darker elements of the room, but the lamp shades are blown out (little or no detail). In the old days of film, we'd probably opt for negative film and then selectively burn and dodge portions of the image to end up with an image that has detail everywhere we want. Today, with digital imaging, we can shoot a widely bracketed set of images and blend them together. By using software, we can take the best bits of various images and blend them judiciously into one "perfect" photo. As with so much of photography and postproduction work, a lot of judgment goes into making the decisions. In the bottom photo on page 180, we have an image where we blended portions of various images; the result was pleasing detail in both the shadows and the highlights.

Robin and Fil made this picture years ago, before there was any software to automate the process. We used *alpha channels* to block the dark parts of the darkest portions of the dark pictures and the lightest portions of the light pictures to blend them together as a whole. Today, the most expensive versions of Photoshop can do HDR for us. We just give the images to the software, and tell the program what we want. Other software can do the same, maybe better, but Photoshop is the one stand-alone image editor that comes closest to doing it all.

We have that software now, and sometimes use it when the existing light in the scene is simply too beautiful to mess with. Still, we don't expect novice photographers to rush out and buy expensive software when what they really need most is another light or two (or six). The point of this demonstration is that we can still do some pretty advanced stuff with fairly primitive tools.

This is a book about lighting, not about Photoshop. Still, the technologies integrate. It is as impossible to divorce lighting from digital post as it once was to separate it from darkroom burning and dodging.

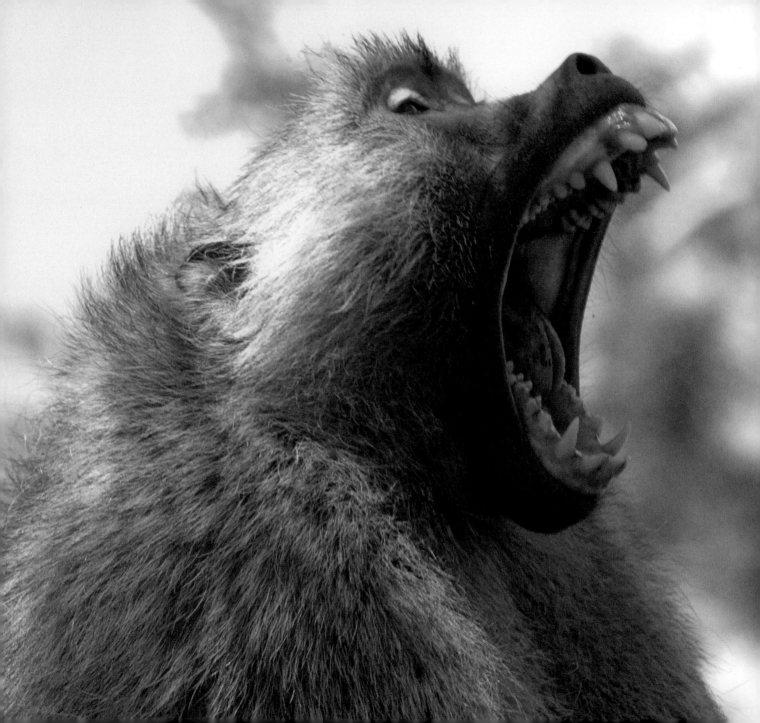

Conclusion

WE'VE COVERED A lot of ground, and we hope there's something for everyone. We welcome your questions and comments at info@moxieandmagic.com.

Now go out and take some pictures. Don't be a monkey; be a human. Use your brain. And while you're at it, have some fun!

Glossary

THIS IS AN introductory book, but a few terms here go a little beyond an introductory explanation. Some readers will be eager for the extra detail, whereas others will not yet want that detail, and they are welcome to skip what they don't need. Just remember that it's here when you need it.

Angle Iron: Cheap bracket, often used for mounting shelves in storage areas. A flat metal rod bent to a 90-degree angle. Available in a variety of sizes. Reflectors can be leaned against angle irons, though it is more secure to use a spring clamp to prevent the reflector from slipping or falling over. Find it in any hardware store.

Aperture: Simple answer: how open the lens diaphragm is. The more open, the more light that passes through the lens and the greater the exposure. Measured in *f-stops*. That's all a novice really needs to know, but some will want more right now.

Technical answer: the focal length of the lens divided by the effective diameter. That's why a 100 mm lens set at, say, f/8 has a much bigger physical opening than a 25 mm lens set to the same aperture, *even though they both admit the same amount of light*. Aperture doesn't just control the amount of light; it is also one of the two factors that control *depth of field*.

Background Light: A light used to brighten a background, often in conjunction with *barn doors* or a *snoot* to control the width of the beam.

Baffle: An additional sheet of diffusion inside a softbox. Usually removable, if less diffusion is needed.

Bar Clamp: An F-shaped clamp, similar to a C-clamp, but generally larger. A threaded screw is at the bottom and can be tightened to hold an item in place. Found in hardware stores.

Barn Door: A tool used to block light; attaches directly to the light. Commercially made models generally have four doors, which can independently be opened as much or little as the photographer desires. Homemade versions will have a black board attached as needed.

Beauty Lighting: Intended to minimize skin texture, it is flat lighting that uses a diffused light above the camera and usually a reflector, sometimes a second diffused light source, beneath the camera. Most effectively used for head-and-shoulder portraits.

Blue Glue: Originally designed to seal refrigerator gaskets, it has been since marketed under many brand names as a way for parents to temporarily put up their children's art without damaging the wall. In photography, it is used to hold lightweight items in place without worry of damage when removed. The term is photographers' slang, so you may have to show store clerks the picture in this book to find it. Found in hardware, school supply, and art supply stores.

Boom: A stand with an adjustable arm that allows things to be placed over the subject without showing in the photograph. Heavy- to medium-weight booms support lights or, in video, microphones. Lightweight, often homemade booms support reflector cards or *gobos*.

Bounced Light: A lighting style that points a flash at a white ceiling or wall rather than directly at the subject. Produces a larger light source without additional equipment. If there's no white wall or ceiling nearby, we can also carry a large white card or an *umbrella* or tape up a white sheet.

Bracketing: Making several exposures using different *f-stops*. This may be done to determine the best exposure for a given scene. (A technically "perfect" exposure is not always the best exposure from an artistic view.) Essential for *high dynamic range imaging*, where selective portions of each image will be blended into one photo.

Bright Field: Term used when photographing glass and there is a light background and the glass needs a dark outline. Also used in various scientific fields, including imaging with no visible light.

Built-in Flash: Flash that is part of the camera. May pop up or may literally be built into the camera body.

Bulb (camera setting): Setting used for longer exposures than the camera has settings for and the photographer times the exposure manually. Also used for long exposures where we need multiple flash exposures for a single image.

Burn: To darken a portion of an image. In the darkroom, burning was done by exposing portions of an image to additional light from the enlarger in order to darken an area of a print, using hands or cardboard wands to block the light from certain areas. Today, we do this with software, but with radically different techniques. The digital *burn* and *dodge* tools do not work nearly as well as the older darkroom equivalents, but we can do much more using alpha channels and their powerful extension, layer masks, to select an area to burn. This goes beyond simple lighting, so see other books, including books from Focal Press, for further discussion.

Butterfly Lighting: Lighting style similar to beauty lighting, except this technique uses one diffused light above the subject's head with either no additional light or just a little fill, so that there is a butterfly-shaped shadow under the subject's nose.

Cable Release: Cord that attaches to the camera, which is used to take a photograph by pressing a plunger on the free end of the cable. Good for avoiding camera movement in almost any shot, essential for long exposures or when the photographer cannot be near the camera (e.g., for a self-portrait). Available in a variety of lengths.

Camera Left: Term used to indicate anything that is to the left of the camera from the photographer's perspective from behind the camera. The opposite direction from what the subject may consider camera left. An arbitrary distinction, but an essential one when photographers are talking to one another about where they put the light.

Camera Right: Term used to indicate anything that is to the right of the camera from the

photographer's perspective from behind the camera. See *camera left*.

Canvas Background: A photographic background made of canvas that is usually hand painted, sometimes screen printed. Frequently used in portraiture. Usually abstract with random, softly blended areas of similar colors, but it can also have scenes (such as a library full of books).

Catchlights: Highlights in the eyes.

C-clamps: These steel clamps get their name from their shape. A threaded screw is at the bottom and can be tightened to hold an item in place.

Circular Reflector: Used to bounce light. Commercially made, it is round and folds up for easy transport. Generally comes in two different sides (e.g., one side is white and the other silver), so a photographer gets two different reflectors in one. Also comes in other colors, such as gold and black. The black side, an obviously poor reflector, serves as a *gobo*.

Color Temperature: Every light source has a particular temperature that determines the color of that light source.

Matching the light source to the related setting on a digital camera results in a photograph that looks pretty much as we see the scene (i.e., fairly neutral). Mismatching the camera setting and the light source will result in images that have odd colors. (Not necessarily bad.) Measured in degrees Kelvin (K). Color temperature is always used to measure "white" light, meaning light with a reasonably even mix of all colors in the visible spectrum. That "reasonably even mix" can vary greatly from one light to another, however.

Contrast: The difference between the lightest and darkest areas of a scene. In lighting, this often means the difference between the *main* light and the *fill*, if any. Note, though, that the subject can affect the contrast as much as the lighting; a diamond with bright facets, lying on black velvet, is likely to be a high-contrast scene no matter how we light it.

Cookie: Short for cucoloris (with several spelling variations). To still photographers, usually a flat piece of cardboard or wood with holes in it, used to create uneven lighting. Some small metal cookies are used inside of

highly focused theatrical lights for a similar effect.

Cucoloris: See *Cookie*.

Dark Field: Term used when photographing glass and there is a dark background and the glass needs a bright outline. Also see *bright field,* its opposite.

Daylight: In general terms, unclouded light any time during the brighter hours of the day or any photographic light that approximates the same *color temperature*. Daylight is used to describe light when sun is directly overhead on a clear day. In technical terms, light of $5500°$ K *color temperature*. Also used to describe the camera setting at which the camera assumes the light source is daylight balanced.

Dedicated Flash: Flash that can be controlled by the camera's programmable functions. Intelligent versions also communicate back to the camera what they are seeing, allowing the camera to revise settings *during* the exposure.

Depth of Field: The distance between the closest and the farthest subject that we are willing to consider acceptably sharp. The words *willing* and *acceptably* are, of course,

judgment calls. They depend not only on the subjective opinion of the viewer but also on the size of the reproduced image; an image that appears sharp at a small size may appear unsharp when it is enlarged. The mathematical formula for depth of field reflects this complexity and literally (we're not joking here) includes a term representing the "circle of confusion." For practical purposes, depth of field is determined by two factors: aperture and image size. The smaller the aperture, the greater the depth of field; the smaller the image size, the greater the depth of field. Many photographers already understand the effect of aperture: a picture shot at, say, f/16 will have a lot more depth of field than the same scene shot at f/2.8. The effect of image size is less apparent but still easy to understand. Many photographers believe that wide-angle lenses produce more depth of field. They really don't: they simply produce smaller images and smaller images have greater depth of field. If we move the wide-angle lens close enough to the subject to produce the same size image, the depth of field is the same as that of a longer lens from a greater distance.

Diffuse Reflection: Light reflecting from the subject equally in *all* directions, *regardless* of the direction from which the light comes. Uncoated white paper and nonglossy white cloth produce a great deal of diffuse reflection. Diffuse reflection is a property of the subject itself and has nothing to do with whether the light source is in any way diffused. Compare with *direct reflection*.

Diffusion: The spread of light. The practical importance is that diffusion turns a small light into a large one. Photographers use both *diffusion material* and *bounced light* to accomplish this.

Diffusion Material: Any of a variety of materials used to diffuse light: tracing paper, white cloth, or commercially produced translucent white plastic (which comes in a variety of densities). Diffusion material makes little lights into bigger light sources, with resulting softer light. Professionally made diffusion material is available in both rolls and sheets.

Direct Reflection: Direct reflection happens in *only one direction* and that direction is the opposite of the angle at which the light strikes it.

Examples include mirrors, bright metal, and water. Compare with *diffuse reflection*.

Distortion: Proportions not being recorded "realistically." Caused by either the lens or the camera viewpoint. *Lens distortion* is sometimes a result of defects in the lens. This is rarely noticeable in today's lenses, except for *very* wide-angle lenses. *Perspective distortion* happens with all lenses. Dependent on camera viewpoint: the closer the camera, the greater the perspective distortion. This leads many photographers to mistakenly believe wide-angle lenses cause distortion. They don't, but *the closer viewpoint* they allow does increase distortion. The effect may be pleasing: a country road, becoming ever smaller in the distance. However, it may be displeasing: a cityscape with tall buildings on the left and right leaning toward the center of the picture. Displeasing perspective distortion can be corrected with postproduction software, sometimes with a significant loss of image quality; may also be corrected without significant loss of quality using *perspective control* lenses or *view cameras,* both increasingly rarely used by current photographers.

Dodge: To lighten a portion of an image. Once done in the darkroom by preventing light from the enlarger striking the paper during part of the exposure. Now done in postproduction work using software. Also see *burn*.

Duct Tape: Cheap, strongly adhesive, easily removable tape used mostly for sealing heating and air conditioning ducts. Photographers use it to hold things in place when no specialized clamp exists or is handy. Often used to tape cables to the floor in a public space to keep people from tripping. More likely to cause damage when removed. Also see *gaffer tape*.

Electronically Controlled Triggering System: Triggers a remote light not attached to the camera by wire. Once always used visible light from another flash, now increasingly replaced by infrared or radio signals. The infrared and radio versions often also allow remote control of the power and other settings of an intelligent flash. A few specialized versions trigger the flash as the subject passes through a laser beam, allowing accurate photography of high-speed subjects.

Exposure: The amount of light striking the electronic sensor (or sometimes, still, the film). Controlled by both the *aperture* and the *shutter speed*. The wider the aperture, the faster the shutter speed can be, and vice versa. Simple concept, but huge implications beyond the scope of a lighting book. *Please* seek other sources of information.

Extension Rings: Tubes that attach between the lens and the camera. They have no optics but do include the electrical connections that allow the lens to function as if it were attached directly to the camera. Used for macro photography by changing the distance of the lens to the image plane, allowing for closer focusing.

F-stop: Simply, the diameter of a lens: the greater the diameter, the more light. More technically correct, the focal length of the lens divided by the diameter. Adjustable by the *aperture,* a sliding ring of thin blades that open and close to control the effective f-stop. But it can also refer to the change in lighting strength, as in, "We reduced the power of the flash by one-half stop." Why the word *stop*? Originally the term referred to a thin metal sheet with a precisely drilled hole, which slid into a slot in the lens to stop part of the light.

Fill Light: Light from a variety of sources used to lighten shadows. Could be a white wall, a piece of white foam board, or a flash.

Filters: Glass or plastic that can screw onto a lens or be placed in a lens hood. Depending on the filter, can alter color, polarize light, soften an image, add starburst, and more. One special filter, the close-up filter, allows the lens to focus on closer objects than the lens focusing mount otherwise allows. Usually of lower optical quality than an *extension ring,* but often acceptable, especially if we use a close-up filter from the same manufacturer that made the lens.

Fluorescent: Long hated by photographers because of unpredictable color variation by manufacturer and by age, these are becoming a significant photographic light source. Nonhousehold, photographic-specialty fluorescent is no longer uncommon.

Foam Board: Lightweight plastic foam sandwiched between two pieces of heavy paper for

protection and rigidity. Cuts easily. Available in white, used frequently as a reflector, and black, used as a *gobo*.

Fome-Cor: Trade name for foam board.

Framed Diffusers: Items that will spread and enlarge light. Made with diffusion material attached to a frame of wood or plastic plumbing pipe. Both are rigid; plastic pipe allows disassembly for greater portability in video, where continuous sources are required.

Gaffer Tape: Strong cloth pressure-sensitive tape. It offers excellent adhesion and removes more cleanly than *duct tape*.

Gel: A thin colored transparent sheet used over a flash. Usually used for both color correction and dramatic color shifting, we also use pure white for diffusion, transparent gray for neutral density.

Gobo: A piece of board that blocks light from striking the lens or restricts light from striking an item in a photograph.

Grid: An assembly of short, small hexagonal or cylindrical black tubes that cover the front of a light source to restrict the spread of light.

Guide Number: The guide number divided by the distance to the subject tells us the aperture. We have to determine the guide number for each flash. Almost obsolete because of the intelligence of today's camera and flash, it may still be worth learning about; it's extremely accurate when the intelligent misjudges.

Hair Light: A light used to brighten the hair. May be a silver reflector, but more often it is a flash used in conjunction with a softbox, grid, or umbrella.

Hatchet Lighting: Lighting style where the light source comes from the side of a subject. Also called *split lighting*. Can accentuate skin texture, but can also produce dramatic images.

Haze: Caused by dirty air and ultraviolet light. It obscures detail in the distance of a scene. Depending on the scene, this can be a good or bad thing: it obscures detail but increases the sense of distance.

HDRI: See *High Dynamic Range Imaging*.

High Dynamic Range Imaging: Known as HRD or HDRI, involves taking a series of images from the same viewpoint with different exposures, which we combine into a single image. Useful when faced with a scene that has a bigger range of light levels than the camera can accommodate without losing detail in either the highlight, shadow, or both.

High Key: Images with light backgrounds. In portraiture, the people usually wear light-colored clothing.

Histogram: A bar chart showing the range of tones in an image, with the dark tones on the left and the light tones on the right. The height of each bar represents how much of that tone is in the image. (In an unmanipulated image, the bars are so close together that they appear to be continuous.) A look at the histogram helps to adjust exposure. Many histograms show tonal values from the darkest to the lightest areas, but not always. A dark scene has most of the bars on the left of the graph, whereas a light scene has most of the bars on the right. This gives us the opportunity to manipulate *exposure* for better image quality.

Had we had camera histogram displays in the days of film, we would have adjusted exposure to put as much exposure as possible at the dark end of the histogram to reduce film grain. Today, we put as much of our tonal range as possible in the right side, highlighting areas of the histogram to reduce the digital *noise* that happens in the shadow areas. Neither of these actions produces an accurate exposure, but they do produce exposures that we can lighten or darken in postproduction to produce a higher-quality final image.

Hot Lights: Tungsten, including quartz-halogen lights that are continuously on, unlike flash, which only supplies light upon triggering. Actually two slightly different *color temperatures,* both of which are yellowish orange. Both are scheduled to become illegal in the United States and probably Europe within a few years because of energy inefficiency. (The exact timing for that move is established but may be renegotiated.)

Hot Shoe: Place where flash is attached to camera. Not a simple mechanical attachment, but always offers at least triggering of the flash. Increasingly, offers intelligent data transfer, allowing the camera to instruct the flash on power setting and more.

Incandescent: Means light from a glowing filament, usually tungsten light. See *Hot Lights.*

ISO (International Standards Organization): A measure of the light sensitivity of film and electronic sensors, a unification of two slightly different older standards, ASA (American Standards Association) and DIN (Deutsches Institut für Normung). Increased film development allows a slight increase in ISO, sometimes producing the illusion of a much greater ISO. All digital cameras can amplify the electronic signal to truly increase the ISO, allowing photos in much lower light. Both techniques significantly reduce the quality of the image by producing increased grain in the film and increased *noise* in the digital recording. See also *noise.* (Note that ISO, ASA, and DIN all have standardized measurement scales for *many* things. Here, we discuss only those most directly concerned with photography.)

Kelvin: A temperature scale measuring the color of light. We could just as easily use Fahrenheit, Centigrade, or Celsius, but the Kelvin scale emphasizes higher temperatures where things begin to glow. The lower the temperature, the "warmer" the color (orange, red); the higher the temperature, the "cooler" the color (blue, green). The traditional Kelvin scale depends entirely on *heat* to produce light. This produces a mix of *all* visible colors, although, clearly, any given temperature produces more of one color, less of another. Electrical sources not entirely dependent on heat, such as fluorescent, once had no true Kelvin measurement because they lacked the full visible spectrum. However, improvements in those sources are beginning to produce a fuller spectrum, and the Kelvin measurement becomes more reasonable for them. For example, while there is no inexpensive 5000° K fluorescent lamp, the D50 lamp comes close enough for many practical purposes. The hardware and electrical supply store versions of D50 cost *very* little more than the less calibrated lamps, so look for them if you want to shoot with available light in your home or office. (There's also some evidence that this more "naturally" colored

light may lead to psychological improvement among workers.)

Key Light: Also known as the *main light*, the brightest light used in making a photograph.

Kicker: A light that strikes the subject from the rear, but also slightly to the side.

LED: Light-emitting diodes are extremely efficient lights, producing a great deal of light from very little electrical current. Once practical only for very small lights such as calculator displays, they are getting bigger, and large groupings of them are now common for larger applications such as automobile taillights. Some photographers are now experimenting with very large groupings for photographic lights. Likely to become a common photographic light source in the foreseeable future.

Lens Hood: Also known as a lens shade. It is used on the end of a lens to block a light from outside the field of view from striking the lens to avoid camera flare and, to a lesser extent, lens flare.

Light Modifiers: Barn doors, snoots, grids, bounce cards, umbrellas, softboxes, gobos: any of a variety of items that alter or amend the light source. Can diffuse the light or restrict it.

Light Stands: Metal stands used to hold flash. Collapse for easy transport. Come in a variety of styles and sizes. For purely photographic purposes, the heavier, the better. Some of these have dollies to make them easy to roll around, and crank mechanisms for raising and lowering heavy lights. For easy travel, the lighter the better. Choose carefully, depending on the features you need most. Most of us compromise between the heaviest and the lightest.

Line of Sight: Mainly concerned with whether a remote flash can "see" the light that triggers it. Optical triggers, using either visible light or infrared, generally need to be visible to the camera to flash reliably, but not always. Sometimes the triggering light can bounce around corners and down hallways to put the external flash in "line of sight" to the triggering light without being in line of sight with the camera. We can also use a synch cord between the light and the trigger to put a small, barely visible optical trigger in view of the triggering light out of sight from the camera. A radio-controlled trigger offers maximum flexibility. The radio signal can sometimes travel right through barriers, which are opaque to visible and infrared light. "Line of sight" doesn't always correspond with what our eyes can see.

Low Key: Images with dark backgrounds. In portraiture, the people wear dark-colored clothing.

Main Light: Also known as the *key light*. Almost always the single brightest light in a photograph.

Masking Tape: Everyone knows about this thin, easy-to-tear paper tape, but we need to remind you that it is also an important photographic tool. Not very strong, but adequate for many purposes, and less expensive than either *duct tape* or *gaffer tape*. Also not very heat resistant and likely to leave an ugly residue on very hot lights. No inherent harm there, but switch to gaffer tape if the appearance of your equipment is important to your clients.

Mylar: A thin, durable DuPont plastic. Commonly used in tape, metallic sheets, and many other products. Photographers often use it as a silver, sometimes gold,

mirror reflector, often attached to foam board for rigidity. We also use translucent white Mylar as diffusion material. Translucent Mylar tends to discolor in dirty air, so photographers who work in dusty industrial environments or smoke in small studios need to replace it periodically.

Neutral Density Material (ND): A filter that may be almost clear or varying degrees of neutral gray. It reduces the intensity of light without changing the color of the light. We seldom use this with a sophisticated flash, which generally allows very low power settings. Still, it's extremely useful on the on-camera flash when we want that flash to trigger an external flash, but want minimal or no visible light from the on-camera flash itself. We can often cover the on-camera flash with enough layers of ND that it has essentially no effect on the lighting of the scene, but the flash is still bright enough to trigger the external flash, especially in studio-like settings where the flash doesn't have to compete with high ambient light.

Noise: Noise is a meaningless random signal that interferes with meaningful data. All electronic circuits experience noise. We

never notice it mixed in with a strong signal—the brightest parts of a photograph, the loudest part of a symphony—but it can be annoying in photographic shadows and soft solos in the middle of the symphony where the noise is strong enough to compete with the primary signal. If you are an absolute beginner, you probably won't even notice this problem, but as you grow, you may become much less satisfied with what you can do. See Chapter 4 for how to reduce noise. The existence of noise may mean we've jumped into the digital age prematurely. Still, we can't blame the pioneers who got us here. Without them, we wouldn't be as far along as we now are.

Off-Camera Flash: A flash not attached to the camera. Sometimes the best place to have the flash is right on top of the camera, but this is more often a mechanical convenience than good lighting. As photographers develop their eye and their skills, they are more likely to want to put the light somewhere else.

Plexiglas: Both a brand name and a generic name for similar products. A thermoplastic that can be clear, translucent white,

opaque white, black, or a variety of colors. Good for a variety of photographic backgrounds.

Polarized Light: Too technically complex for *any* photographic book to thoroughly cover, especially a basic book like this one, but essential enough that we can't leave it out. The good news is that we don't need a physics degree to make good use of the concept. To be as simple as possible, light vibrates in two directions, up and down and side to side. One direction conveys surface (especially glossy); the other direction conveys color. When we look at a surface from a certain narrow family of angles, we see mostly polarized light; from other angles, we see no polarization. We can make use of this. If we look at a lake and like the reflection of the sunlight from its surface, that light is likely to be polarized. We shoot it as is, or add a *polarizing filter*. Turned at the proper angle, the filter eliminates the light that conveys color detail, emphasizing the direct reflection from the water. But suppose we'd rather see the fish beneath the surface? Then we rotate the same filter 90 degrees, eliminating the surface reflection so that we can see the

fish. This is just one example, one where we could equally well decide to capitalize on the polarized reflection or get rid of it. Another example is the blue sky. In bright sunlight, the sky has both polarized and unpolarized reflection. Remembering that the unpolarized reflection conveys color, we put the polarizing filter over our lens and rotate it for maximum color. This makes the sky much bluer without significantly affecting the color of the rest of the scene. Too brief a discussion, but enough that we can start using the principle right away. For a slightly more detailed discussion of polarized light, see the book *Light—Science & Magic*.

Polarizer or **Polarizing Filter:** Depending on the angle of rotation, can either increase or decrease the amount of polarized light making the exposure. May be of high-quality optical glass to attach to the camera lens or of low optical-quality plastic to hang in front of lights. (Beware of the low-quality sheets; some work very well, others offer hardly any polarization at all! Try to get a small sample piece before buying.) See *Polarized Light*.

Popup Flash: Flash built into a camera that is generally out of sight when not needed but that can be opened when needed.

Postproduction: Work done on images after they are captured. It may include burning, dodging, vignetting, color adjustments, and cropping. Used to all be done either in the darkroom or by hand on prints, but now almost always done with software. A very small percentage of this work can still be done better and more quickly on the print, however. Learning to work without the digital tools is a fairly tedious process most photographers don't want to master. Still, it's a good idea to become acquainted with someone who can do this, just in case you need him or her.

RAM: Random access memory. Most people already know this concept, but we need to mention that digital image processing is extremely RAM intensive. Whatever RAM we need to rapidly operate word processing, spreadsheets, and presentation software simultaneously may become impractically slow when we start to process images. Equip your computer with all the RAM you can afford if you intend to process pictures on a regular basis.

Raw: Often written "RAW," because many photographers consider it to be a standard image format like TIFF or JPEG. Not so; one camera maker's raw can be totally different from another's, *and the specifications may be proprietary and secret*. A better format is Adobe's DNG (digital negative) format, because its code is open to all. A few (almost always among the better) camera manufacturers have adopted DNG rather than developing still another raw format. Other very good camera makers persist with their own proprietary raw formats, and there's no way to predict whether this Babel will continue or evolve into a common, universally available format. All of these file formats allow an image file with a wider dynamic range that can be used to produce, say, a TIFF. They preserve the data with minimal loss of information. (DNG compresses with *no* loss of information.) A resulting 24-bit TIFF, with its more limited dynamic range will, indeed, lose information, just as photographers have always lost information when they made a silver-based print. Still, all of the raw formats and DNG allow photographers to change their

minds, return to the original file, and make a new print with a whole new interpretation.

Reflectors: Any of a variety of items that reflect light. Can be as simple as a white or silver board or can be manufactured metal reflectors that fit directly on the light source. Used either to redirect the light or to enlarge the effective size of a small source.

Rembrandt Lighting: Lighting that is placed so a triangle of light appears on the shadow side of a face. Also called *short lighting*.

Rim Lighting: Lighting behind but aimed at the subject that skims the back of a subject to delineate it from the background.

Ring Light: A circular flash that fits on the lens of a camera and completely encircles it. Large versions are most used for beauty lighting. Smaller versions are used for medical photography where we want to see into a small opening (e.g., dental) and forensic photography (e.g., nearly shadowless illumination of small crime scene evidence).

Screw-on Filters: These screw directly onto a lens. Unlike gels used in front of a light, they are made with the highest optical quality.

Seamless: Large, cheap paper background for photography. Available in a wide variety of colors.

Seamless Stand: Consists of two tri-legged adjustable stands and a crossbar that holds seamless paper. Allows for easy portability from place to place. Seamless unrolls from the top. There are other ways to support seamless, which are permanent and sturdier but lack mobility. These cost less than light stands, and, in a pinch, we can use one for a light stand. Still, we'd rather use a sturdier stand for expensive lights and use the seamless stands only for cheap paper.

Shade: Light in an area that does not receive direct sunlight, such as under a leafy tree. Because there is no direct sunlight, the main light is often the open blue sky. Also, a setting on many digital cameras to adjust for the cooler light in shade.

Silver Reflector: Mirror-like surface that reflects light. Could be a shell that fits around a light source, but this could just as easily refer to a foam board reflector with Mylar on it. Because of the shiny surface, more light is reflected back than if a white reflector is used.

Softbox: A boxlike structure, most frequently rectangular, with diffusion material in front and enclosed sides and an opening only slightly bigger than the light attached at the back. It makes a little light bigger and produces soft light. The bigger the softbox and the more diffusion material used, the softer the light areas.

Slave: A trigger cell on a flash, usually sensitive to visible light, but, increasingly, infrared or radio. Slaves allow multiple flashes to fire simultaneously upon the triggering of a first flash. They are essential for use of multiple flash, because plugging multiple flash units into a single *synch cord* risks electrical damage to the camera.

Snoot: Used to restrict light. A snoot generally provides a small circular opening for the light to pass through. Restricts light more than barn doors, but usually less than a grid.

Split Lighting: See *hatchet lighting*.

Spring Clamp: Think of a big metal clothespin. This is a general-purpose clamp,

available in several sizes. Can clamp diffusion material to a stand, a reflector to an angle iron, the back of a suit jacket for a better fit (though actual clothespins often work better here), a gobo to shield a lens from flair, a piece of cloth not made to fit any background stand. Best of all, these are not photographic-specialty clamps and they're available at any hardware store for low prices. We can even get super strong versions when we need them and very flimsy versions when those are good enough. These are a bargain that pays off in unexpected ways when we need them. Get a handful.

Strobe: Traditionally, any electronic flash. Increasingly today, an electronic flash that uses an incandescent modeling light to let us see approximately what the flash will do.

Synch Cord: An electrical connection between the camera and a remote flash (and "remote" depends on the length of the cord). The camera shutter triggers the flash. This is the cheapest and most reliable way to trigger the flash, but, for the safety of our camera, we can trigger only one flash. Any additional flash needs to be triggered some other way. Also, very long cords increase the likelihood that someone will trip over the cord. These are good tools, but use them judiciously.

Tonal Range: The difference between the lightest and the darkest area in a scene. If the difference between the two is too great, we lose either highlight detail or shadow detail or both. What is "too great"? That depends on the camera: some can record greater tonal ranges than others. Recording a greater tonal range does not get us out of trouble though. Sooner or later, we're likely to want to print the image on a piece of paper that does not allow such a great tonal range. We have to make a judgment call. What do we need to keep? What are we willing to lose? Can we digitally *compress* the tonal range of the scene to fit the tonal range of the paper? Of course, we can, always, if we recorded the full tonal range when we shot it. Still, too much compression can make the image look flat. Ansel Adams's *The Negative* is a good guide for beginning to make these judgments, even if we never intend to shoot a piece of film.

Tripod: Three-legged support for a camera. Generally, the sturdier the better.

Tungsten: See *incandescent*. Produces yellowish orange light, but with a full visible spectrum. Some colors are brighter than others, but they are all there.

Umbrella: Umbrella-shaped reflectors that are used with light sources to spread and diffuse the light. Come in a variety of sizes and styles (white/shoot-thru, silver, and black-lined). Easily portable because they fold up.

Index

Page numbers followed by *f* indicates a figure.

A

Alpha channels, 76, 180
Antiglare-coated lenses, 128, 129
Aperture, 96
 adjustment, 178
 background and, 96
 star effect, 105
Automatic color adjustment, 33, 62,
 see also Color adjustment

B

Background light, 55, *see also* Main
 light
 barn door, 51
 bottle, 161
 and flash, 55
 gobos, 126
 and grid, 54, 56
 high key images, 125
 reflector, 115
Background shadow, 94
Barn door, 51, *see also* Gobo
 background light control, 115, 125
 glass, 157
 Velcro, 52
Beauty lighting, 26, 118, 119*f*,
 see also Lighting
Black-and-white images, 58, 105*f*,
 see Grayscale images
Blue glue, 7, 8*f*
Bounce, 32, 82, *see also* Light, sizing
 card, 35, 37
 ceiling, 33
 diffuser on flash, 41
 fill card and, 34
 reflector, 35

umbrella, use of, 35
wall, 32–33
 from white ceiling, 32*f*
Bracketing, 178
Bright-field lighting, 154
Broad lighting, 112
Built-in flash, 5*f*
 shot with, 5*f*
Bulb, 172
Butterfly lighting, 118

C

Camera
 focus, 98
 placement, 98
camera-right business, 4
Catchlights, 13
Circular reflector, 39, 39*f*
 advantage, 39
 folded, 39*f*
Color adjustment, *see also* Color
 temperature
 auto balance setting, 62
 automatic, 33
 in camera, 62
 custom white balance, 62
 manual, 33
 night time photo, 87*f*
 tungsten and daylight white
 balance, 67–68*f*, 70–71*f*
Color temperature, 61, *see also*
 Kelvin
 cool colors, 62
 daylight, 61
 tungsten, 61
 warm colors, 62

Commercial photographers, 15
Continuous light source, 167
Convert to blue (CTB), 74
Convert to orange (CTO), 73
 use of, 74*f*
Cookies, 49, *see also* Gobo
 homemade, 49*f*
 wooden, 50*f*
Cropping, 114
CTB, *see* Convert to blue (CTB)
CTO, *see* Convert to orange (CTO)

D

Dark-field lighting, 152
Depth of field, 96
Developing photographers, 15
Diffuse reflection, 86, 141
Diffused light, 162
Diffusion, 42
 gobo, 46
 Roscoe sample pack, 42–43, 42*f*
 Strobist pack, 43
Diffusion material, 19, 44, 82,
 see also Diffusion
 duct tape, 44
 framed diffusers, 45–46
 gaffer tape, 44
 position, 44
 umbrella, 46–47
Direct reflection, 86, 141–142
 unpolarized, 142
Directors of lighting (DLs or LDs), 47
DLs or LDs, *see* Directors of lighting
 (DLs or LDs)
Duct tape, 44
Dynamic range, 177

E

Electronically controlled triggering system, 172
Eyeglasses, 128–130

F

Family of angles, 142–144
Feminine vs. masculine, 115
Fill card, 34
Fill light, 11–12, 26, *see also* Main light
Flare, 126
Flash, 16, 175, *see also* Profile lighting
 adjustable flash coverage, 47
 automated systems, 16, 17
 diffuser with, 102
 flat background and, 55f
 homemade grid on, 53f
 selecting right, 17
 small diffuser on, 41f
 trigger, 27–31
Fluorescent lights, 71–72, 175
Foam board, 36f
 Fome-Cor, 35
 Mylar, 35, 36f
Fome-Cor, 9, 35, *see also* Mylar
Found light, 92
Framed diffuser, 144
Framed diffusers, 45–46

G

Gaffer tape, 44
Gels, 42
 application, 74f, 75f
 CTO, 73
 for dramatic color, 73
 Roscolux colored, 43f
 Strobist gel collection, 72

Glass, 151
 background, 153, 156
 bright-field lighting, 154
 camera position, 153
 dark-field lighting, 152
 without diffusion material, 161f
 light placement, 162
 with liquid, 157
 off-camera flash, 155f
 with paper label, 158, 159f
 on Plexiglas, 152f, 154f
 shorter lens, 158
Gobo, 46, 47, 105, *see also* Diffusion
 barn door, 51
 black card, 48f
 cookies, 49
 glass with paper label, 160
 homemade, 49
 between main light and glass, 152
Gradient neutral density filter, 75–76
Grayscale images, 110
Grids, 51, *see also* Homemade grid; Snoot
 background light, 56
 uses, 54

H

Hair light, 11, 113–114
Hard shadow, 79
 small lights, 80
 texture, 80
Hatchet lighting, 109
Haze, 103
Haze filter, *see* UV filter
HDRI, *see* High dynamic range imaging (HDRI)
High dynamic range imaging (HDRI), 177

High key lighting, 120
 flare, 126
High-speed photography, 171
Homemade grid, 53f, *see also* Grids
 on flash, 53f
 making, 52
 supplies for, 52f
Household bulbs, 69

I

In-camera flash
 glass on white Plexiglas, 154f
 neutral density material, 154f, 155
 undiffused, 152
Incandescent light, *see* Tungsten light
Infrared trigger, 30, 30f, *see also* Trigger, flash
 disadvantages, 31
Intelligent flash, 16, 25

J

Journalistic photographers, 15

K

Kelvin, 62, *see also* Color temperature
Kelvin temperature scale, 62
Key light, *see* Main light
Kicker lighting, 116

L

LEDs, *see* Light-emitting diodes (LEDs)
Lens and light placement, 146
Lens filters, 58
 gradient neutral density filter, 75
 polarizing filter, 58, 75
 size, 58
 UV filter, 58

Lens hood, 99
Light
 amending or mixing, 97
 screw-on polarizer, 98
 sunlight, 63
 types, 61
Light, sizing, 32, 47
 bounce, 32
 circular reflector, 39, 39f
 diffusion, 42
 foam board, 36f
 Fome-Cor, 35
 Mylar, 35, 36f
 softboxes, 40
 umbrella, 35, 37
Light and shadow, 79
 black vs. white, 86
 diffusion material and subject, 82
 distant lights, 80
 hard shadows, 80
 hard-edged shadows, 81
 reflection, 86
 small lights, 80
 smaller light and texture, 84
 soft-edged shadows, 81f
Light blockers, 47
Light meters, 126
Light modifiers, 6
 fill light, 11
 hair light, 11
 mirror, 7
 white reflector, 8
Light sources, 175
 advanced, 176
 flashes, 175
 florescent, 175
 LEDs, 175–176
 tungsten, 175
Light-emitting diodes (LEDs), 175–176

Lighting, see also Profile lighting
 background light, 115
 beauty, 118
 bright-field, 154
 broad, 112
 butterflies, 94, 95f
 butterfly, 118
 children, 95
 dark-field, 152
 diffuser with flash, 102
 eyeglasses and, 128–130
 flat, 100
 groups, 131–134, 132–133f
 hair light, 113–114
 kicker, 116
 for kids and adults, 125
 low key vs. high key, 120
 metal, 146
 pets, 135–139
 portraiture, 107–108
 rim, 116
 short, 111
 split, 109–110
 wrinkles, 127
Light-sensitive trigger, 28, see also
 Trigger, flash
 disadvantages, 29–30
 infrared trigger, 30, 30f
Low key lighting, 120

M
Main light, 9, 12, see also Light
 modifiers
Manual color balance, 33
Metal, 141
 diffusion material position, 143
 family of angles, 142–144
 flat, 144–146
 polished, 142

reflection, 141
round, 147–149f
saw, 144–145f
Mirror, 7
Modern flashes, 10
Motion, 165
 dancer, jumping, 166f
 fireworks, 166f
 freezing, 171, 171f
 hands moving through space,
 169–170f
 light source, 167
 setup, 173f
Mylar, 7, 35, 36f, see also
 Fome-Cor
 advantage, 37

N
Night time photo
 in mixed light, 87f
Noise, 87
 high megapixels, 88f
 increase exposure, 88
 low cost camera, 88f
 software packages, 88

O
Off-Camera flash, 13, 25
 away from diffusion material,
 123
 benefit, 26
 and built-in flash, 26
 diffusion material as main
 light, 121
 fill light, 26
 on light stand, 26f
 main light, 25
 manual and automatic, 25
 metal, 147

neutral density material and
popup, 124
popup flash, blocking, 122
undiffused, 152
One-flash setup, 13
Open shade, 94

P
Photographic boom, 59, 114, 155
Photographic store, 23
Photography
adults, 121–122
architecture, 104–105
butterflies, 94, 95f
children, 95
flowers, 101
glass, 151
groups, 131–134, 132–133f
metal, 141
motion, 165
pets, 135–139
portraiture, 107
postproduction work, 117
Photography tools, 24
bounce, 32
bounce card, 35, 37
circular reflector, 39, 39f
clamps, 59
diffusion material, 44
flash trigger, 27–31
foam board, 36f
gels, 42
need for, 57
off-camera flash, 25
softboxes, 40, 40f
stand, 59
Photoshop, 180
Polarizing filter, 58, see also Lens
filters

Portrait photographers, 15
Portraiture, 107
camera heights, 120
catchlight, 121
Postproduction, 117, 138,
176
lighting, 176–177
softwares, 177
Profile lighting, 3
diffusion material, 19
face and light, 19–20
flash, 16–17
light addition, 16
light modifiers, 6
model, 3
paper and light, 20
position, 3
size and picture quality, 18
size control, 13

Q
Quartz-halogen lights, 68, 166

R
Radio trigger, 31, 31f, see also
Trigger, flash
advantage, 31
disadvantage, 31
Reflection, 86
Reflector, 149, see also Bounce
circular, 39, 39f
shade background, 97
umbrella, 38, 38f
Refraction, 64
warm tones by, 64f
Rembrandt lighting, 111
Rim lighting, 116
Roscoe sample pack, 42–43, 42f

S
Shadow, 79, see also Light and
shadow
face shape, 121
hard-edged, 79, 81
sharp edge, 80
soft-edged, 81f
within subject, 83
Short lighting, 111
Silver reflector, 10, see also White
reflector
Sitter wear solid colors, 120
Slimming effect, 133
Snoot, 57, see also Grids
homemade, 57
Soft shadow, 80
Softboxes, 40
homemade, 13, 14f
medium manufactured, 40f
small manufactured, 41f
Split lighting, 109–110
Stage-right, 4
Star effect, 105
Still life, 25
Strobist gel collection, 72
Strobist pack, 43–44
Studio portrait, 107
Sun light, 12, 79, 91, see also Main
light
advantage, 17
advantages, 91
air pollution impact on, 64
color, 64
color adjustment, 62
dappled light, 93
disadvantages, 91
early afternoon light, 63f
early evening, 65f
early morning, 64f

Sun light, (*Continued*)
 sunrise and sunset colors, 63
 sunset, 66*f*
 white building, 67
Synch cord, 27, *see also* Trigger,
 flash
 disadvantages, 27–28

T
Test light, 143
Texture, 83
 black subject, 85*f*, 86*f*
 reflection, 86
 smaller light, 84
 sunlight and household lamps, 83
 white lace, 83*f*, 84*f*
Transition lenses, 130
Translucent, 19
Transparent, 19
Trigger, flash, *see also* Flash
 homemade, 168

inexpensive, 28*f*
infrared, 30, 30*f*
light-sensitive, 28
manually trigger, 170
radio, 31, 31*f*
sensitive, 29*f*
synch cord, 27
Tripod, 108, 165
Tungsten light, 67*f*, 68, 167, 175
 CTB, 74
 CTO, 73
 daylight vs., 69
 vs.daylight white balance, 67*f*
 vs.household lamp, 68*f*
 temperature, 61, 62

U
Ultraviolet, 58
Umbrella, 35, 37, *see also* Bounce
 black-backed, 38*f*, 39
 as diffuser, 46–47

as reflector, 38
silver, 38
white, 38, 38*f*
UV filter, 58, 103

V
Vignette images, 14

W
White board, 149
White foam board
 alternative, 14
White reflector, 8, 10
White shower curtain, 19, 42,
 see also Diffusion material
White translucent white filter, 44
Wireless flash trigger
 alternative, 14
Wireless radio control, 98
Wrinkle, 127
 soft focus filters, 127